Messy Art Teacher Sites

For free art lesson ideas and tips visit
messyartteacher.wordpress.com
or video art tips
youtube.com/messyartteacher

Messy Art Teacher Press
PO Box 2844
Richmond Hill, GA 31324

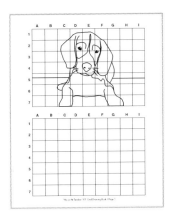 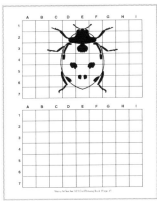 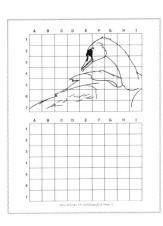 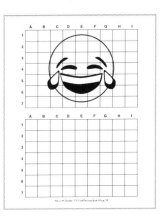

This book belongs to

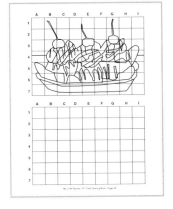 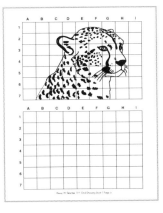 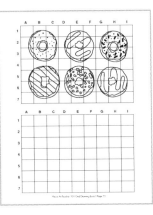 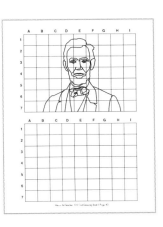

Directions

Recreate the drawing in the bottom grid. The letters and numbers on the side of the grid act as coordinates, so you can find the same square. Look at the top grid and find the square that you want to start with.

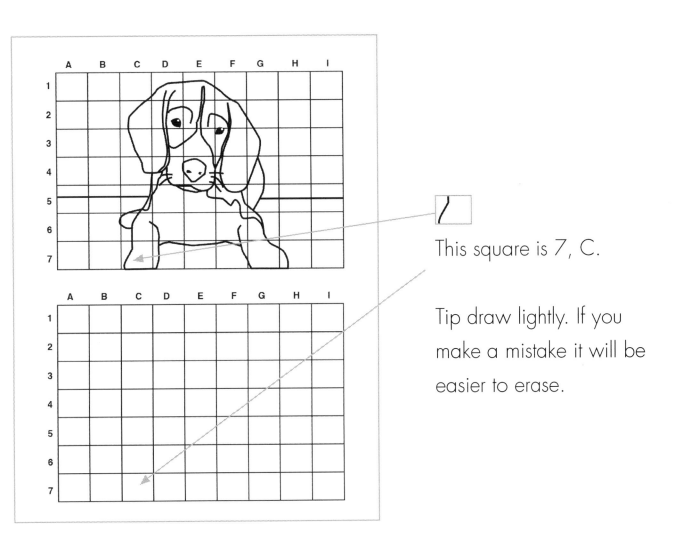

This square is 7, C.

Tip draw lightly. If you make a mistake it will be easier to erase.

Drawing on a grid makes it easier to break down a complex image into smaller parts. Draw with a pencil, and when you finish you can color it in. Take a photo of your finished grid drawing and share with the world.

Bonus page 105 Make your own grid drawing sheet and challenge a friend!

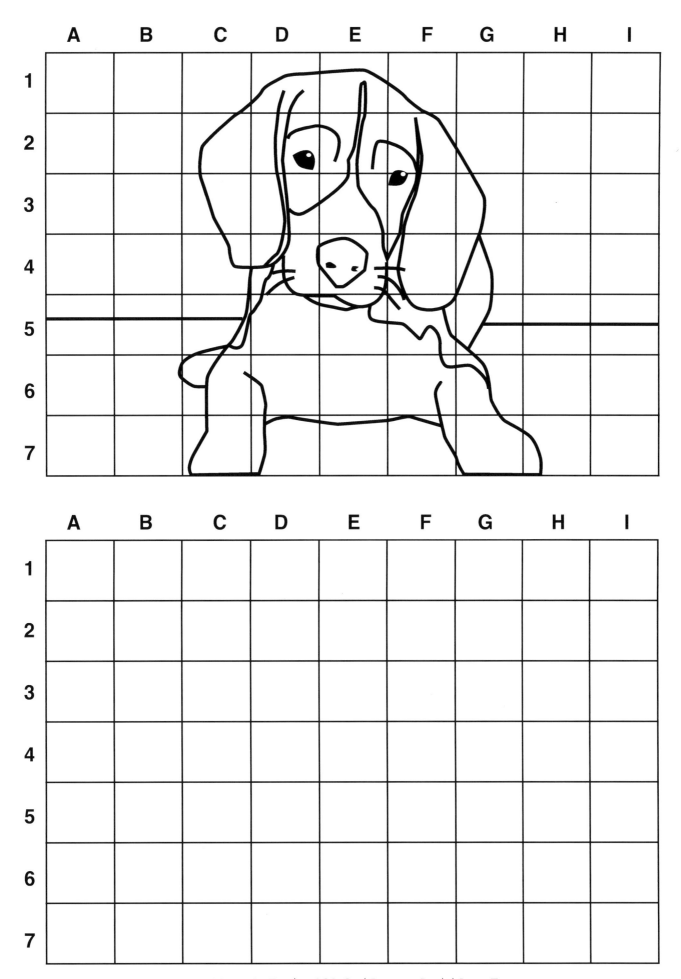

	A	B	C	D	E	F	G	H	I
1									
2									
3									
4									
5									
6									
7									

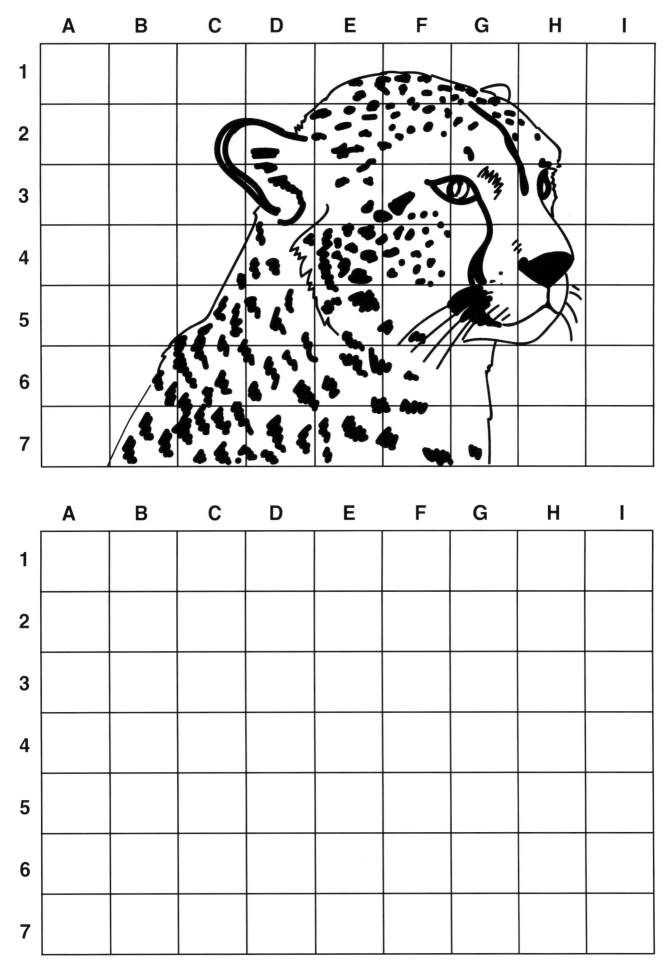

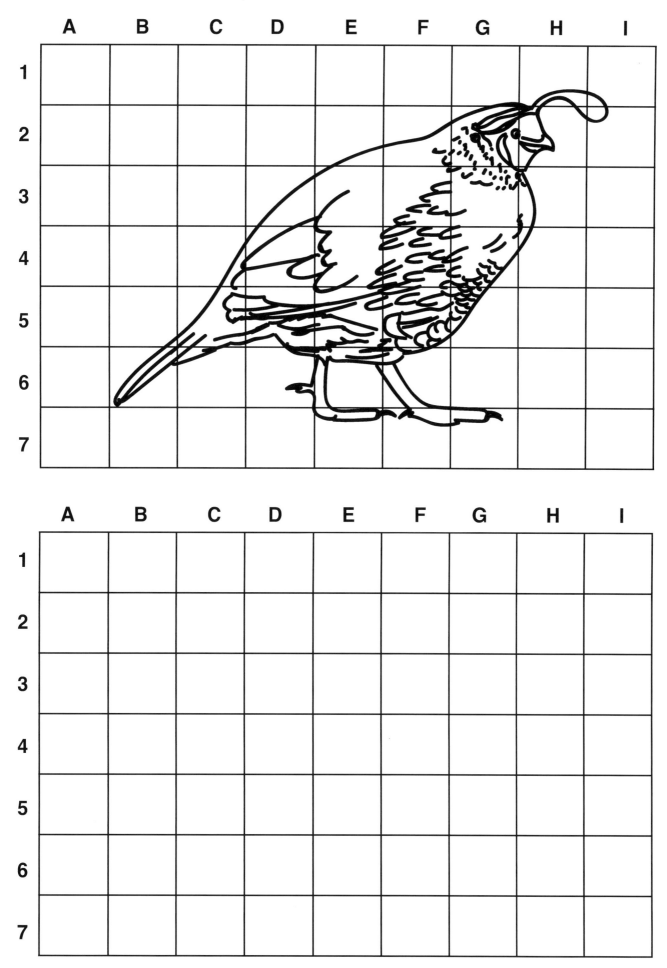

	A	B	C	D	E	F	G	H	I
1									
2									
3									
4									
5									
6									
7									

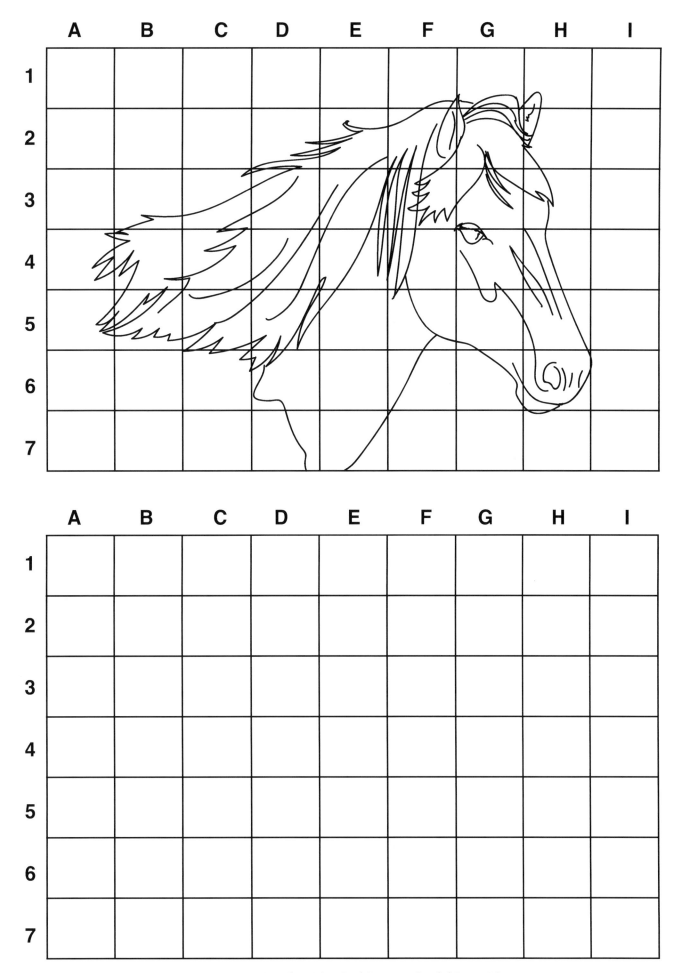

	A	B	C	D	E	F	G	H	I
1									
2									
3									
4									
5									
6									
7									

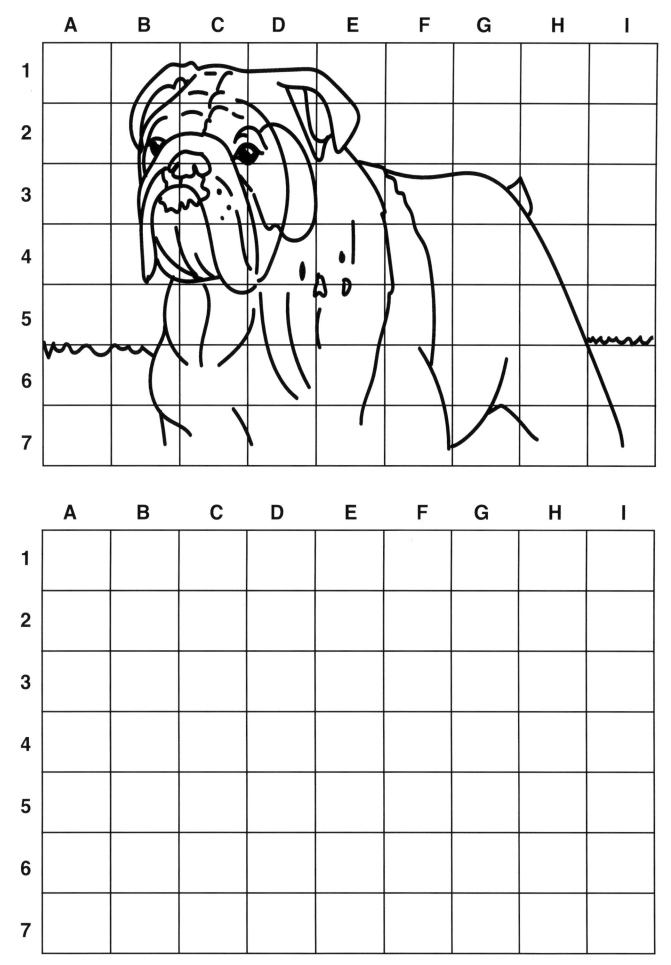

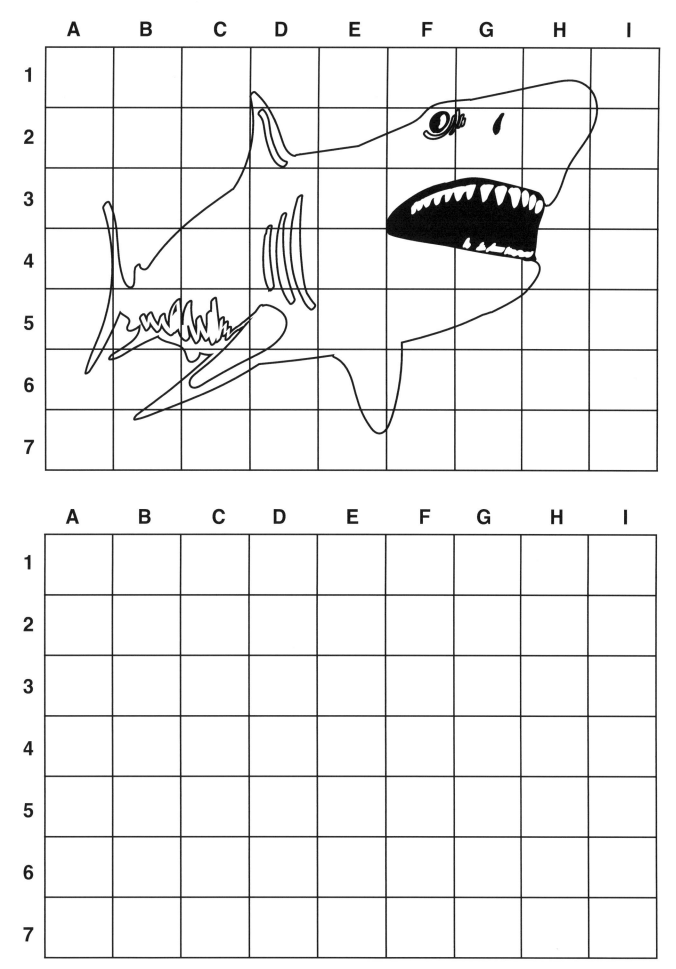

	A	B	C	D	E	F	G	H	I
1									
2									
3									
4									
5									
6									
7									

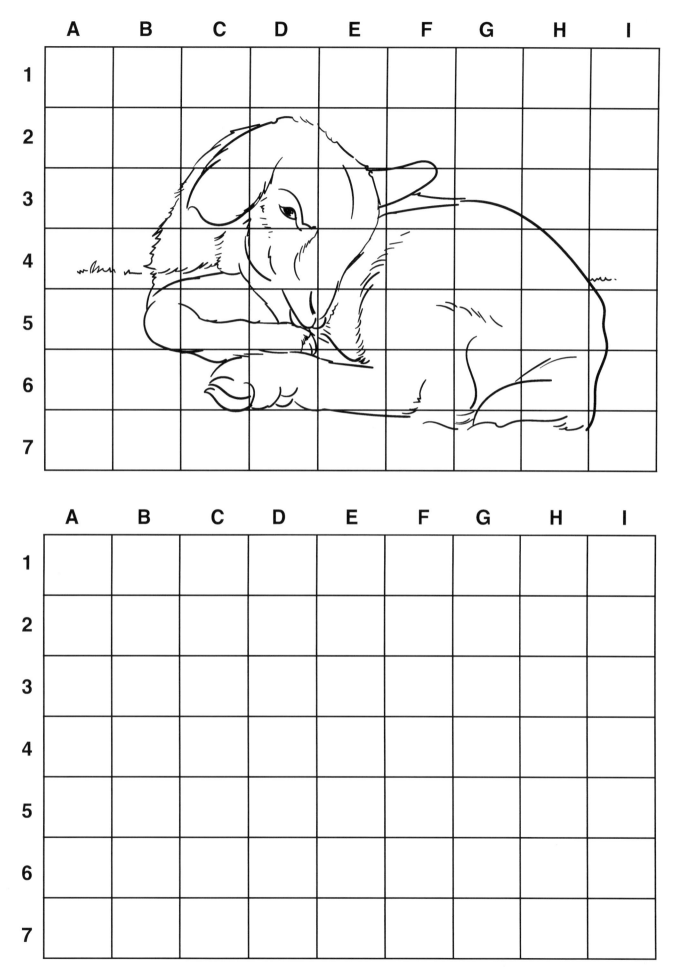

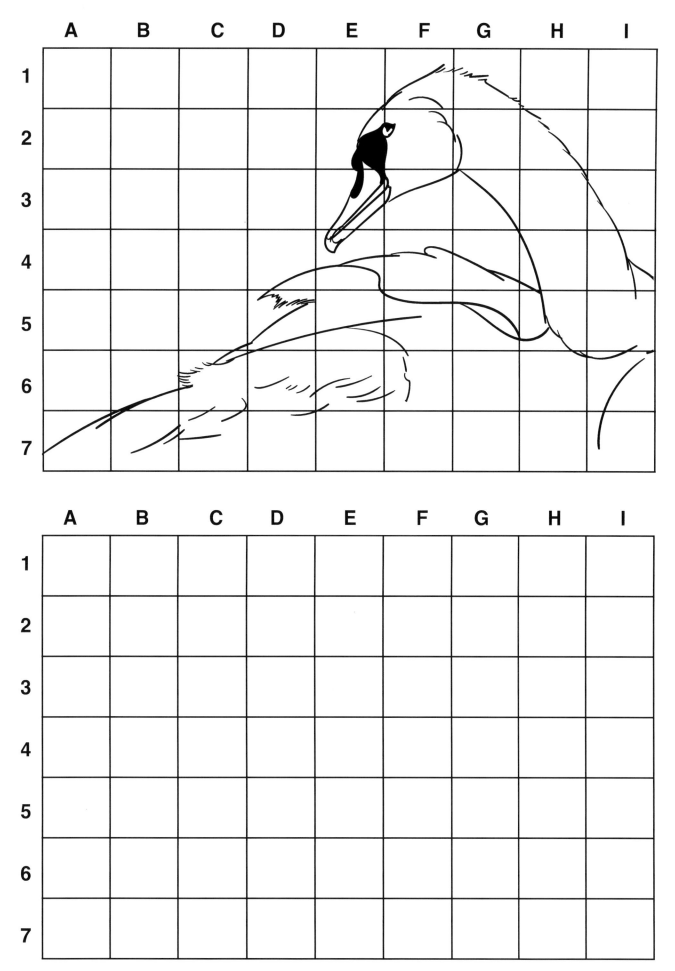

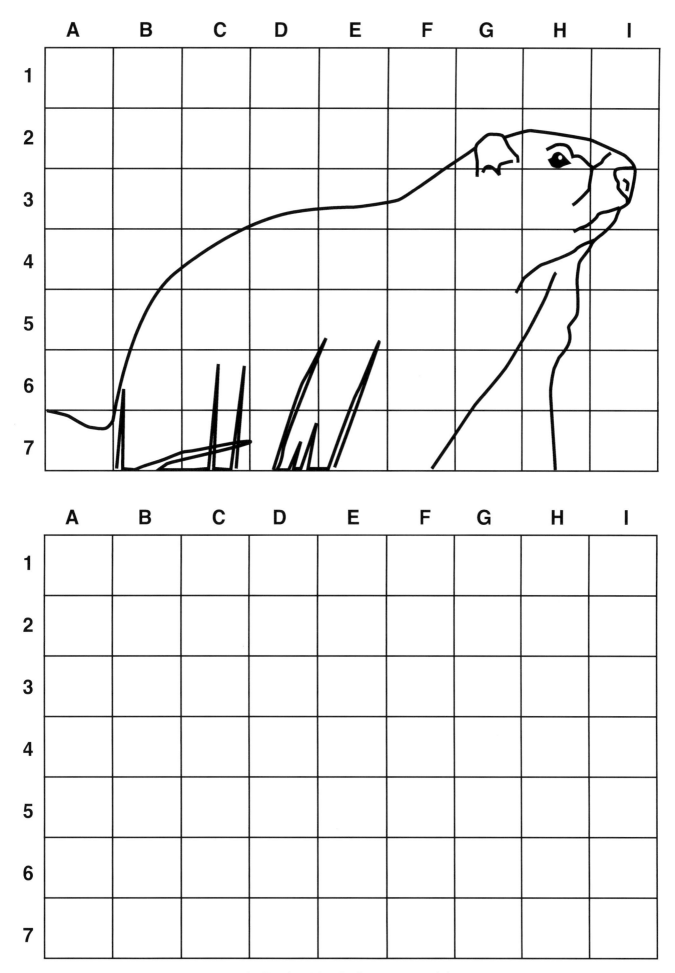

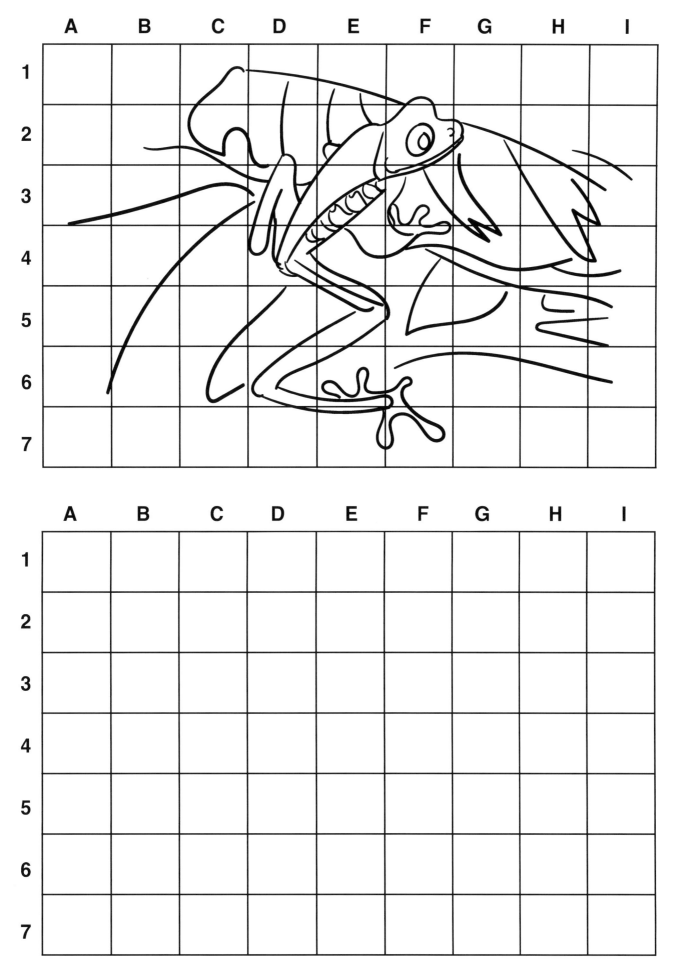

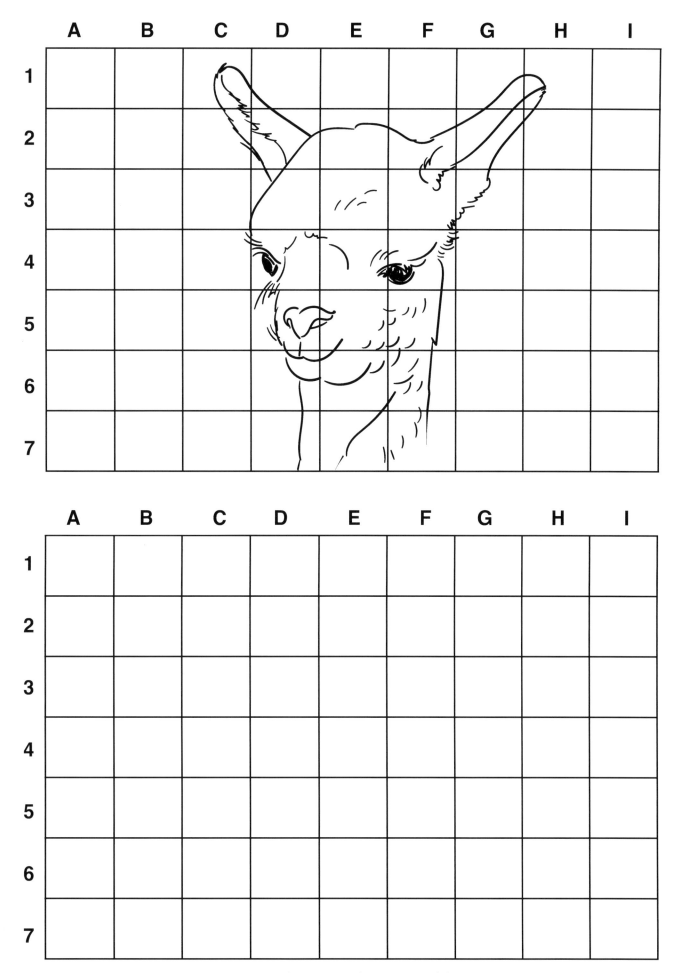

	A	B	C	D	E	F	G	H	I
1									
2									
3									
4									
5									
6									
7									

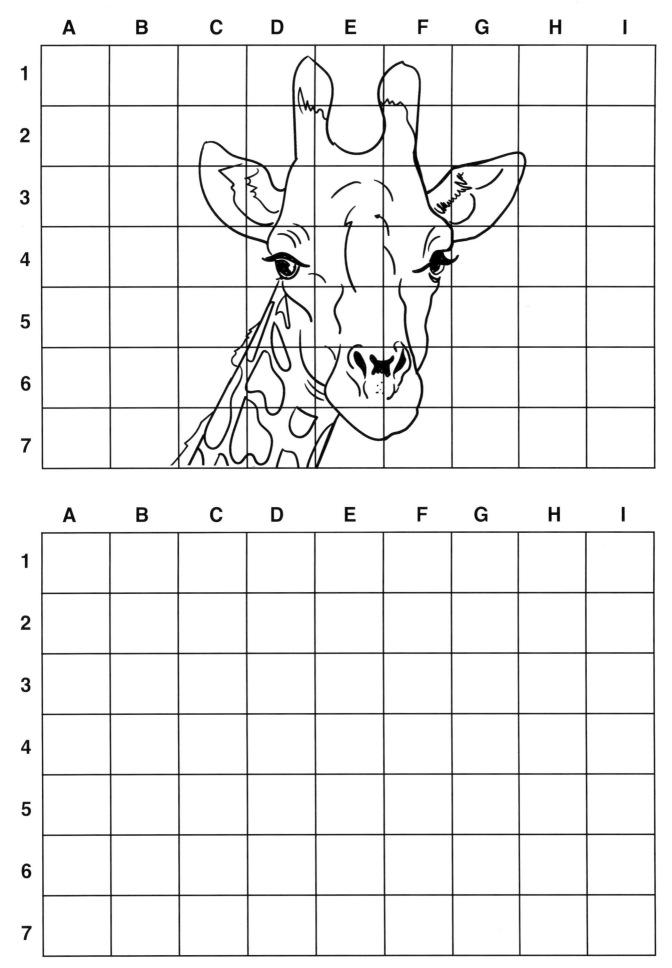

	A	B	C	D	E	F	G	H	I
1									
2									
3									
4									
5									
6									
7									

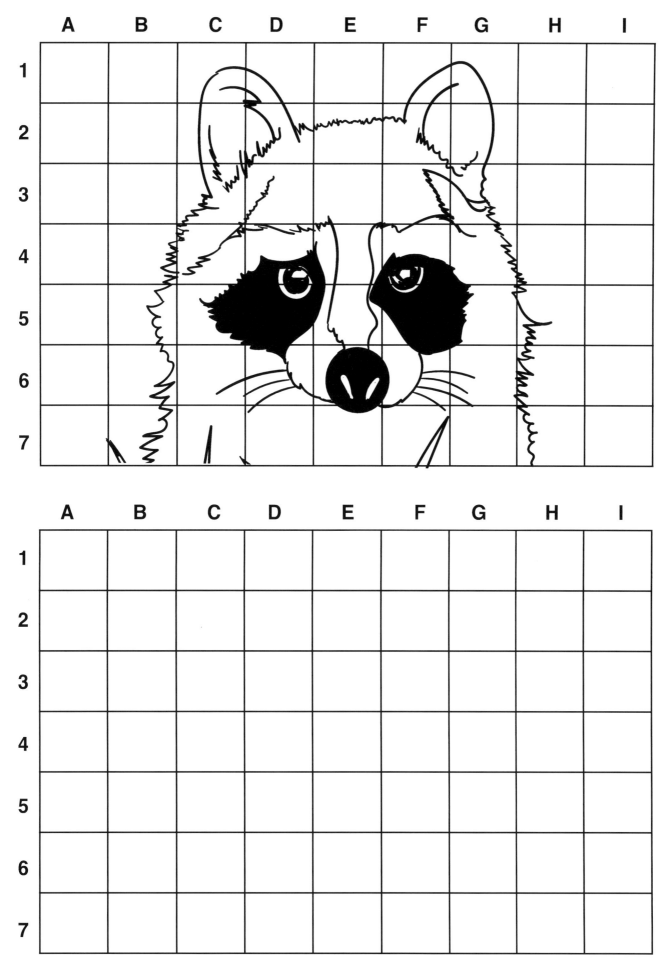

	A	B	C	D	E	F	G	H	I
1									
2									
3									
4									
5									
6									
7									

	A	B	C	D	E	F	G	H	I

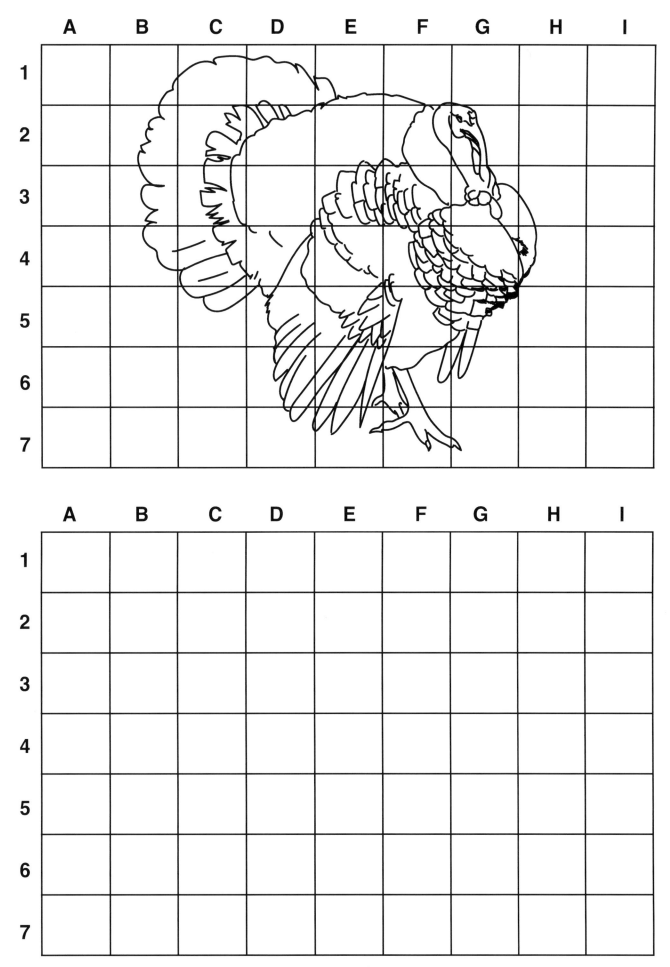

	A	B	C	D	E	F	G	H	I
1									
2									
3									
4									
5									
6									
7									

	A	B	C	D	E	F	G	H	I
1									
2									
3									
4									
5									
6									
7									

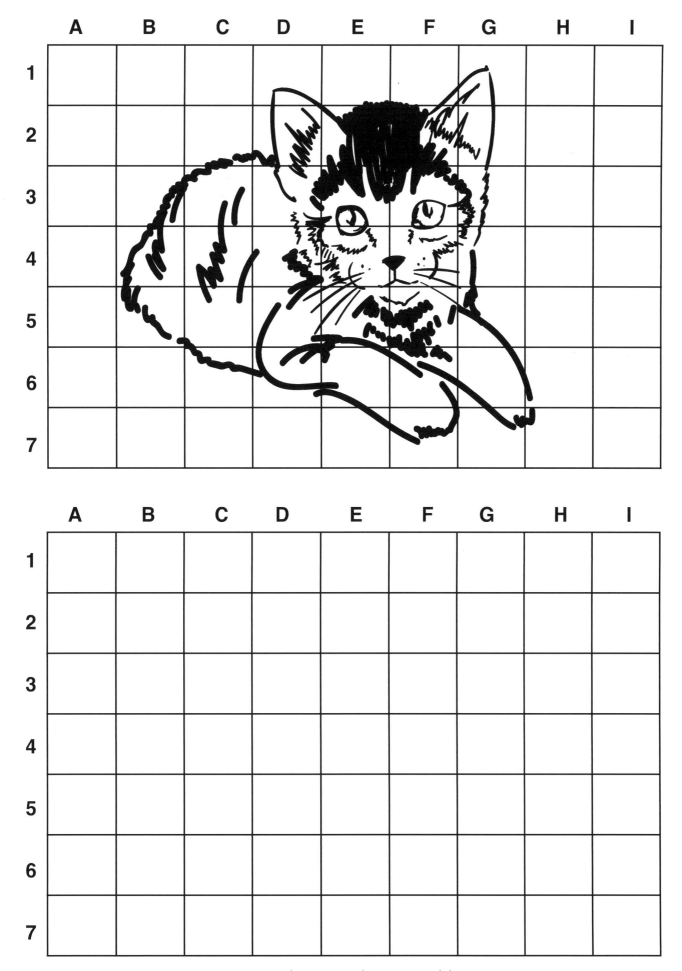

	A	B	C	D	E	F	G	H	I
1									
2									
3									
4									
5									
6									
7									

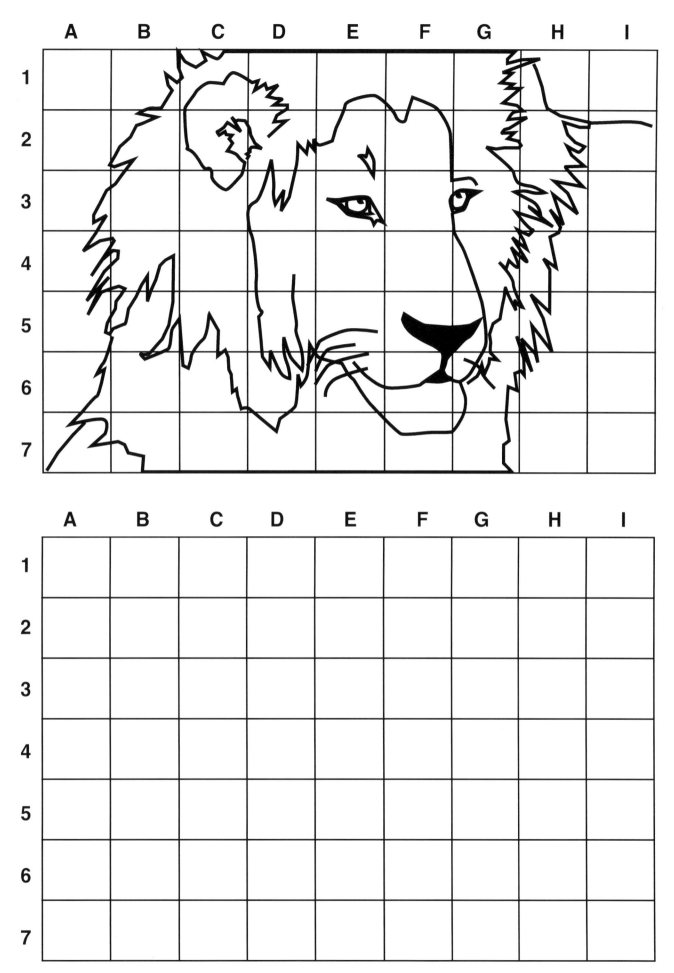

	A	B	C	D	E	F	G	H	I
1									
2									
3									
4									
5									
6									
7									

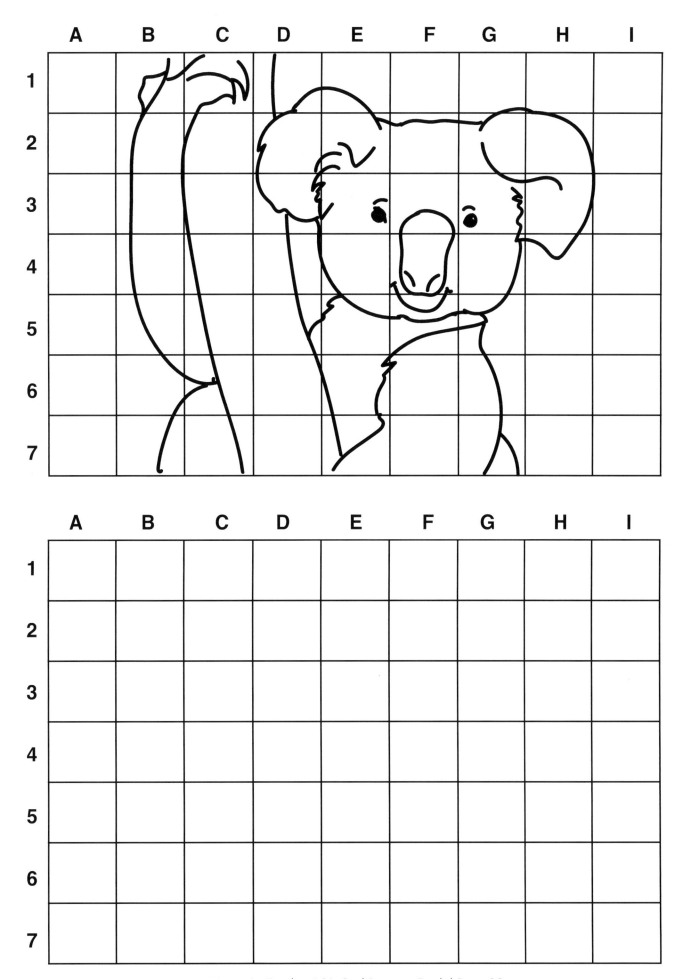

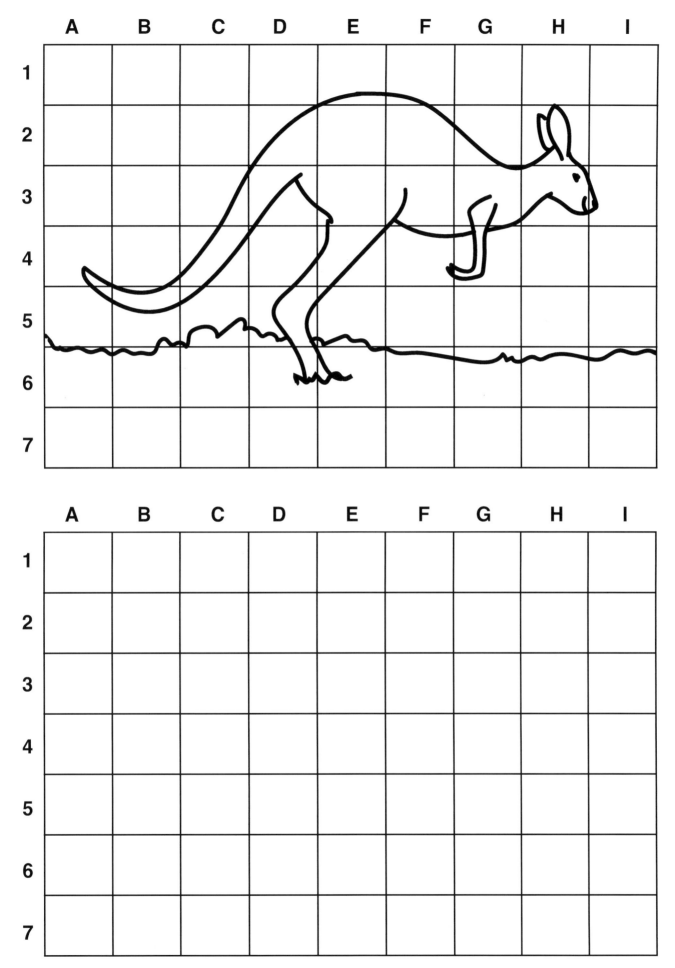

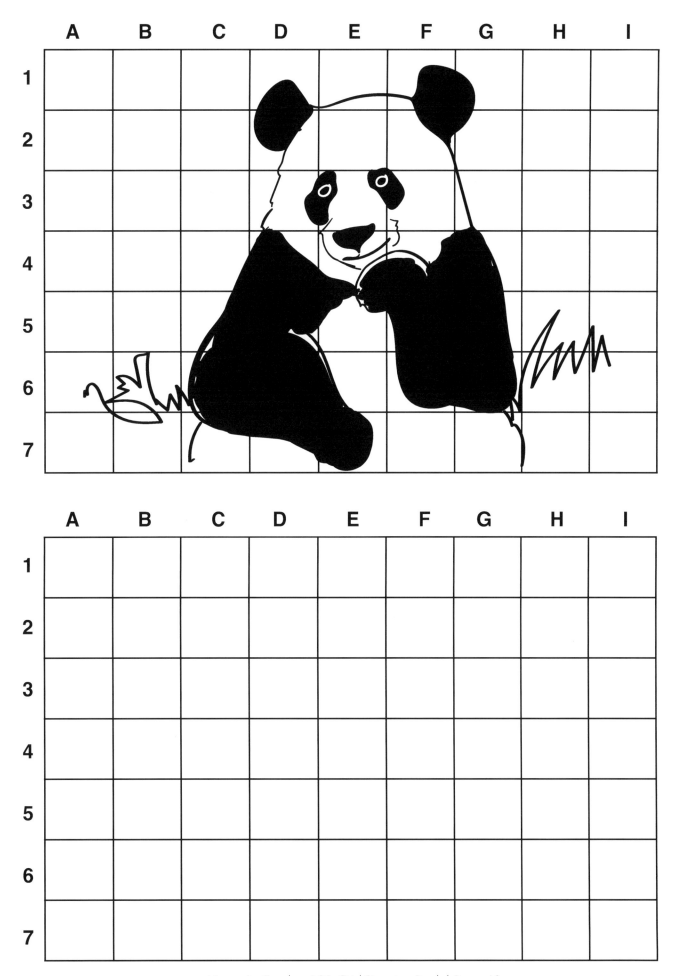

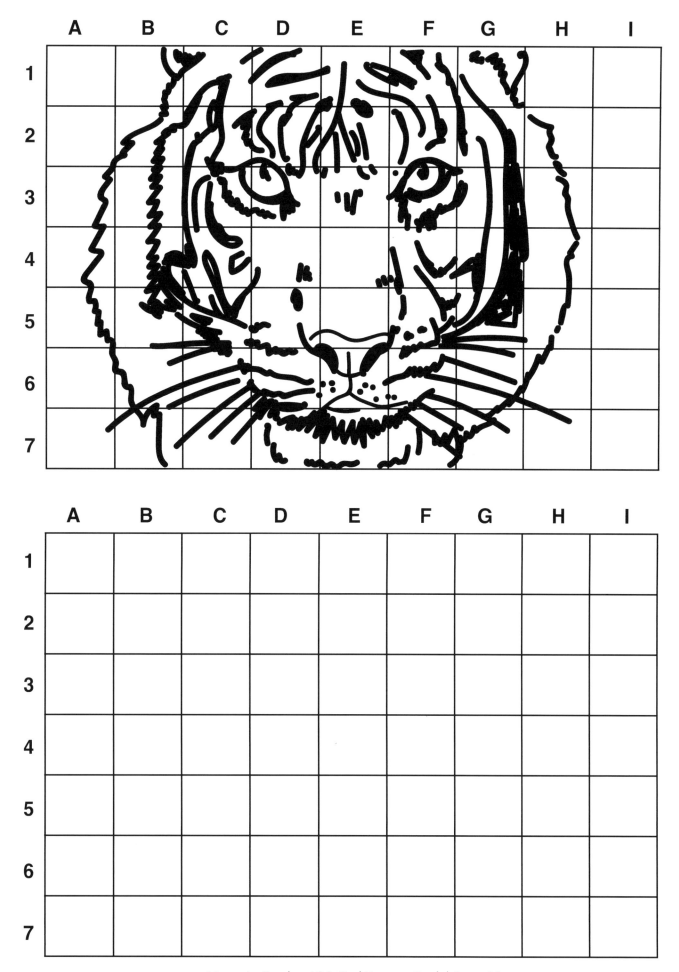

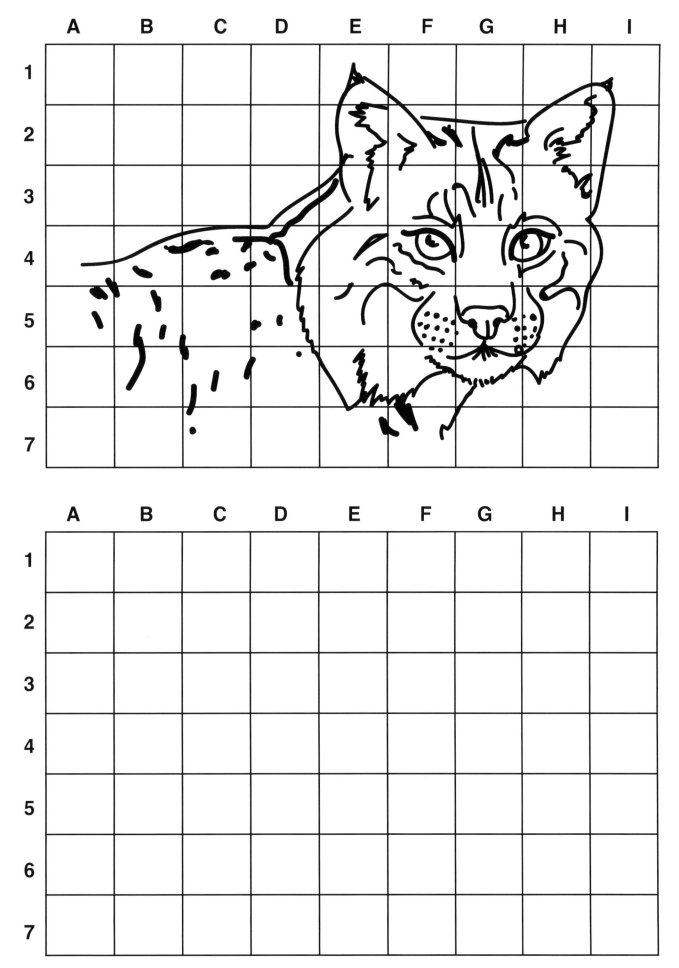

	A	B	C	D	E	F	G	H	I
1									
2									
3									
4									
5									
6									
7									

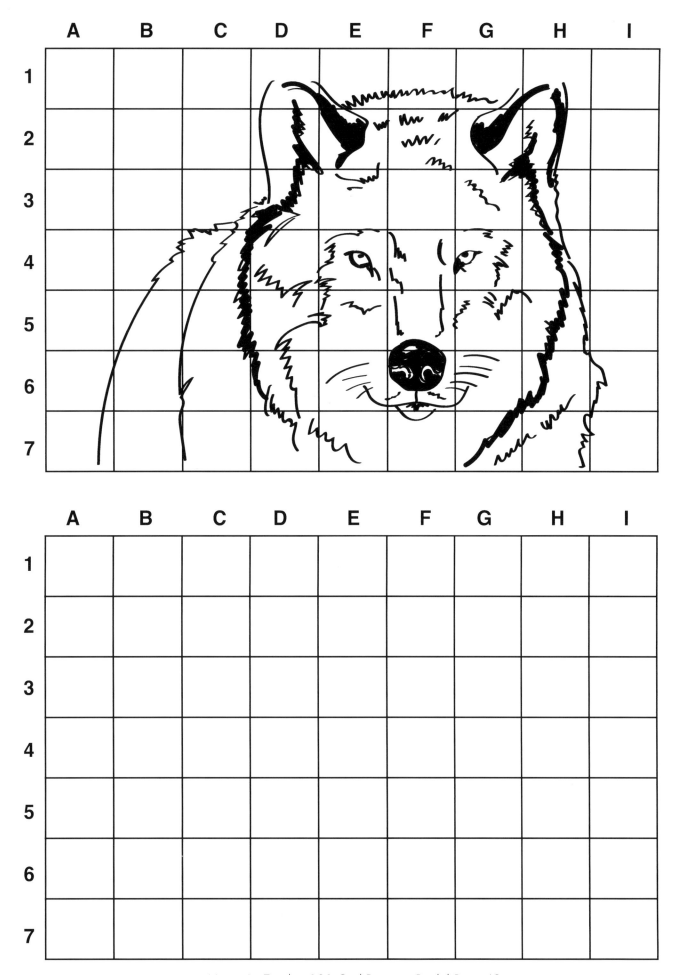

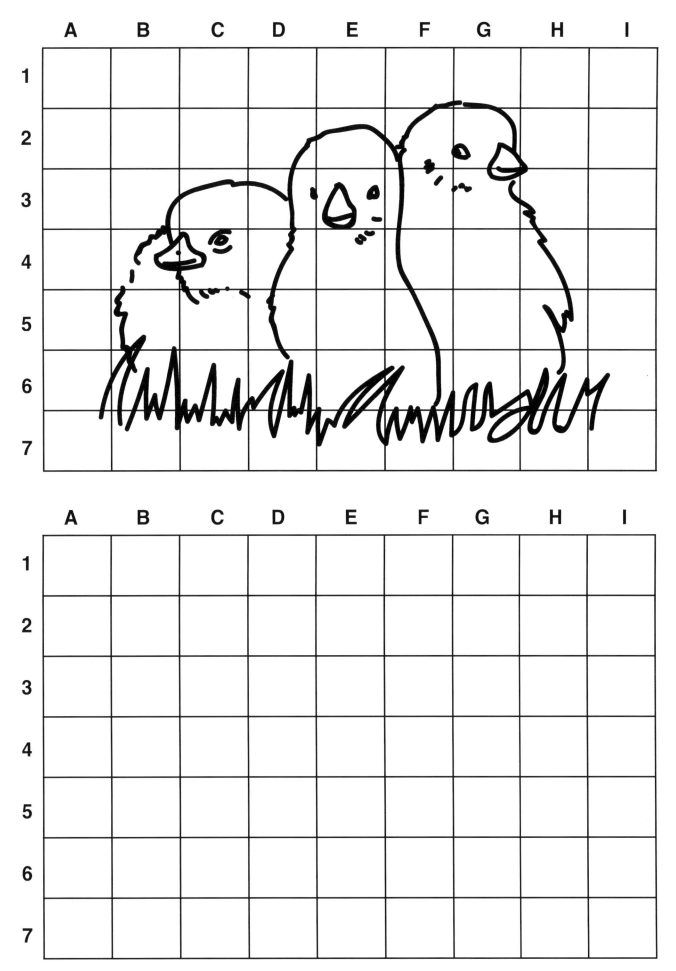

	A	B	C	D	E	F	G	H	I
1									
2									
3									
4									
5									
6									
7									

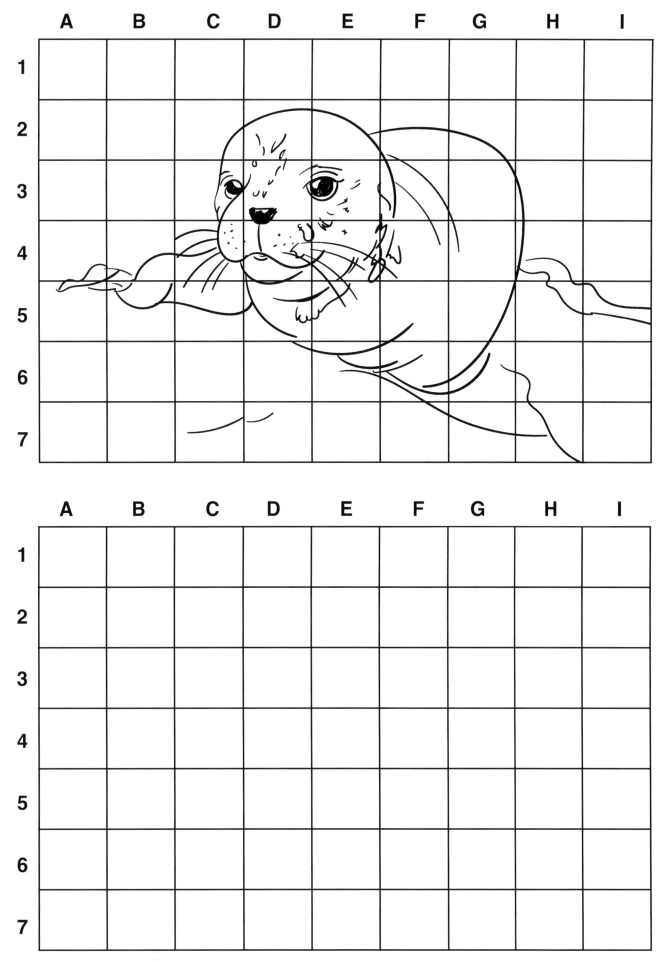

	A	B	C	D	E	F	G	H	I
1									
2									
3									
4									
5									
6									
7									

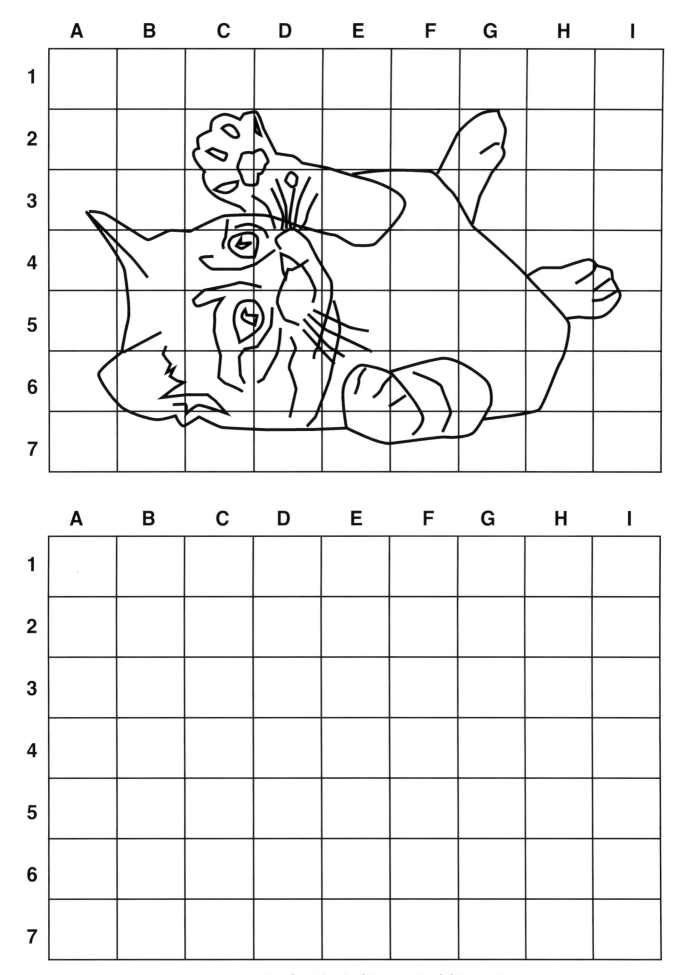

	A	B	C	D	E	F	G	H	I
1									
2									
3									
4									
5									
6									
7									

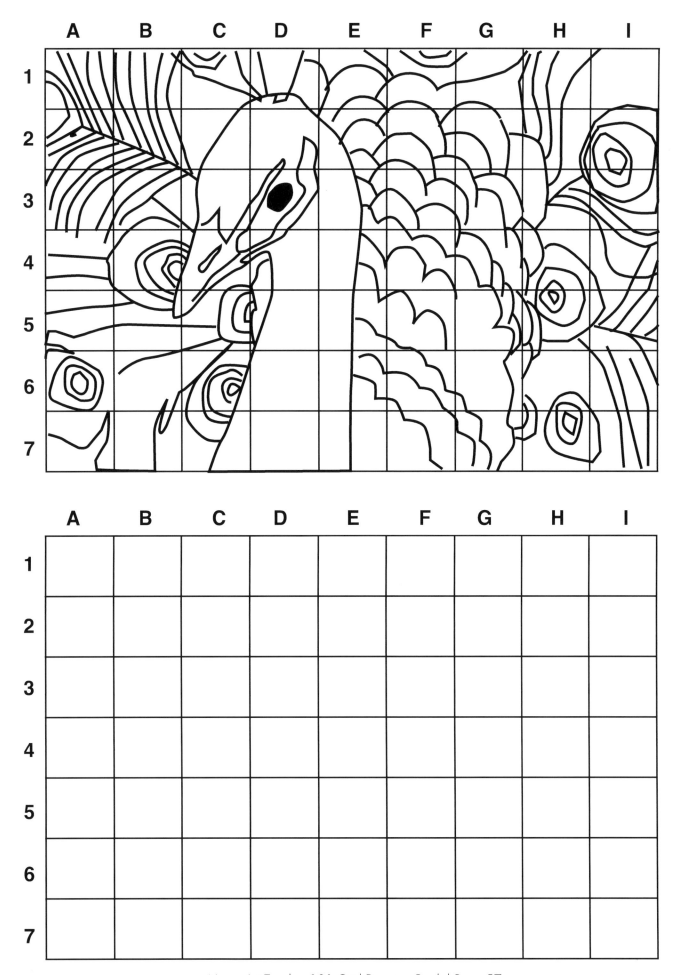

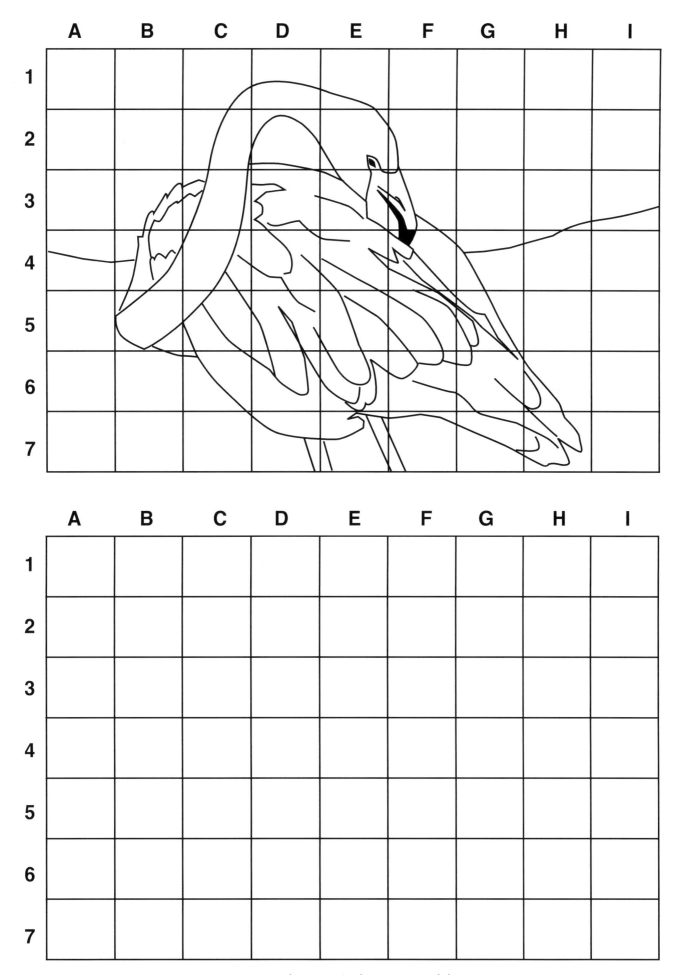

	A	B	C	D	E	F	G	H	I
1									
2									
3									
4									
5									
6									
7									

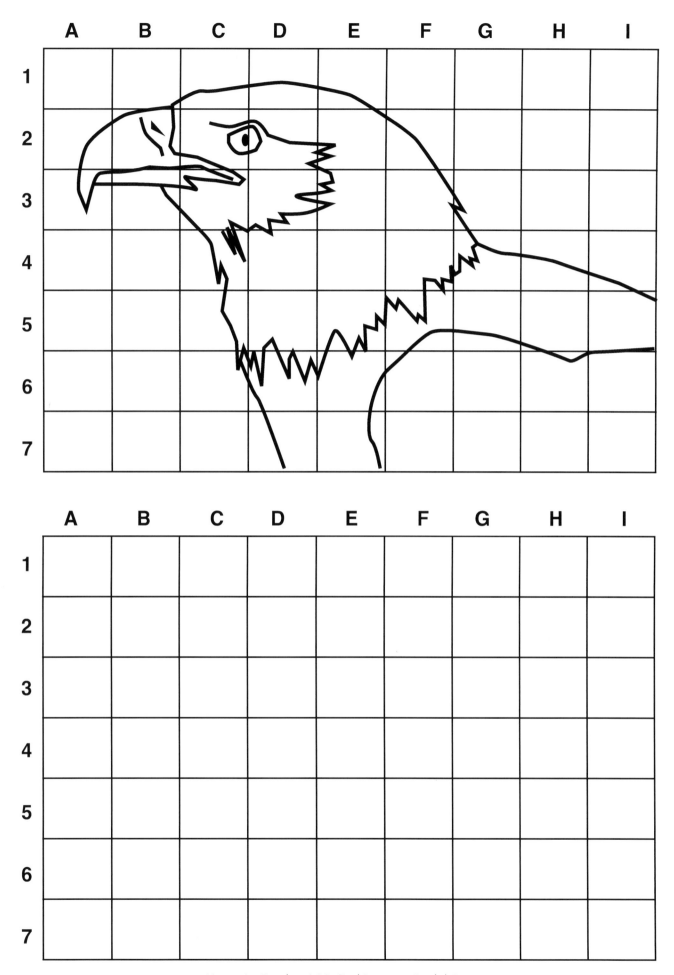

	A	B	C	D	E	F	G	H	I
1									
2									
3									
4									
5									
6									
7									

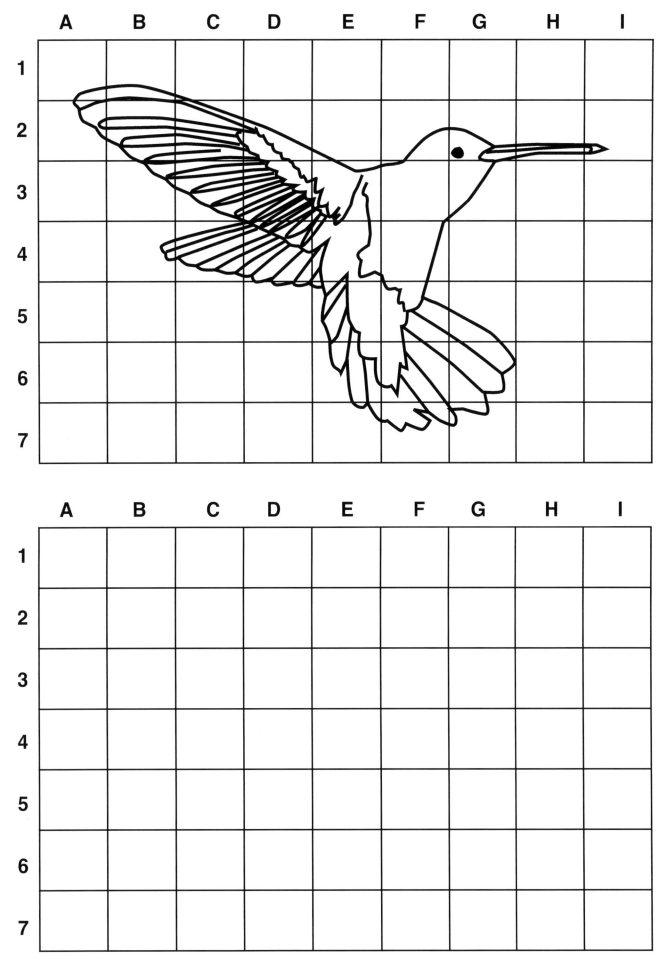

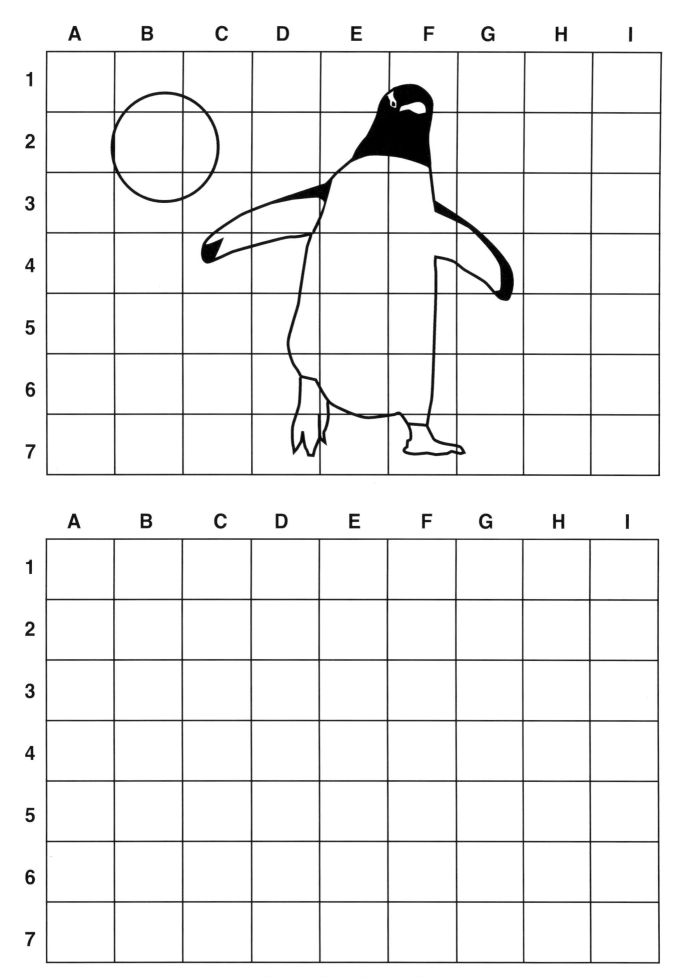

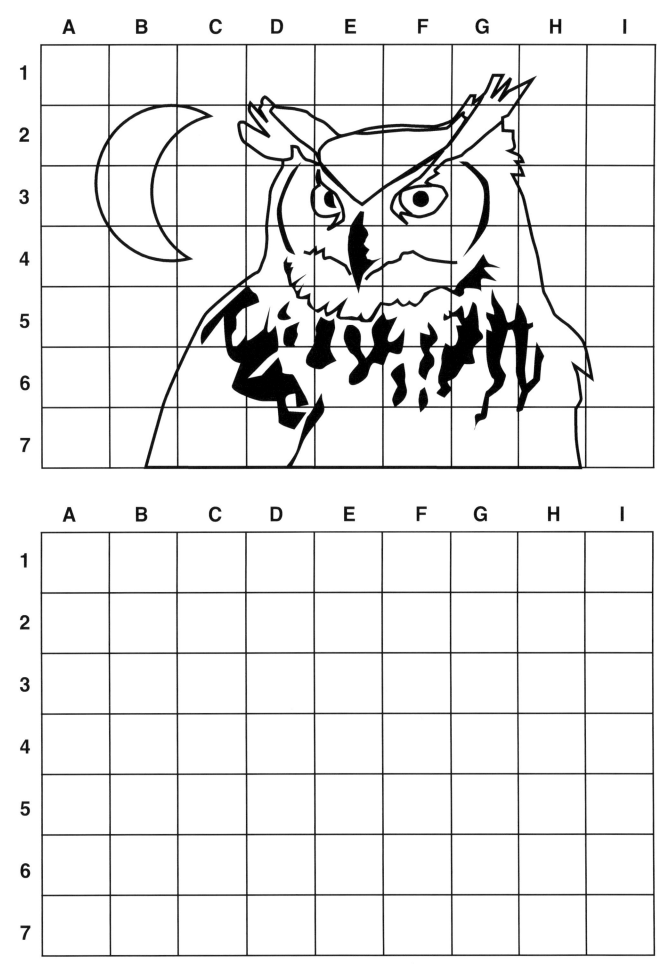

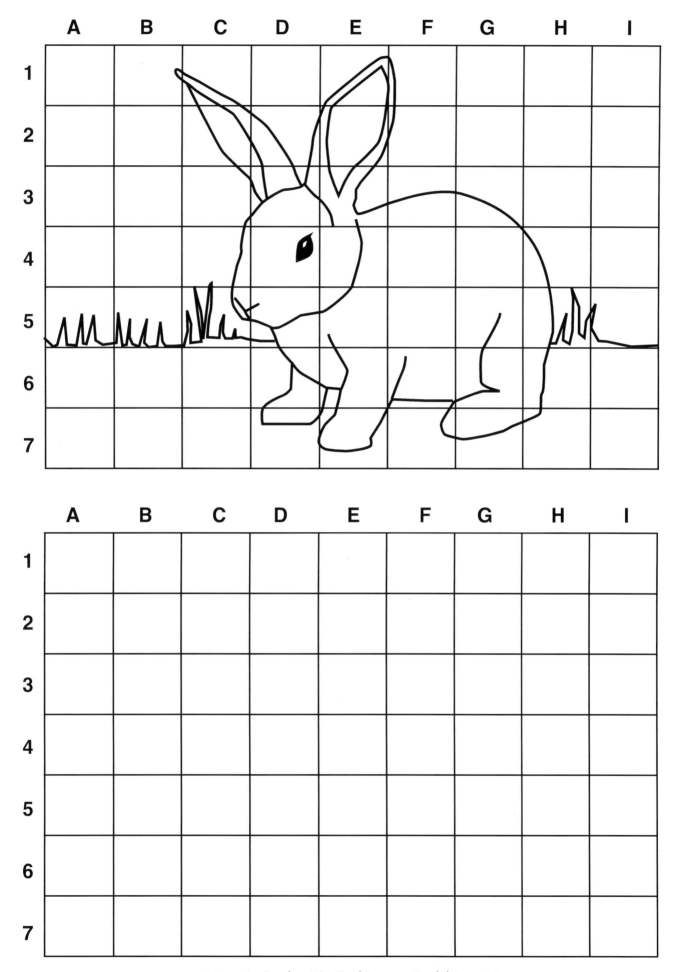

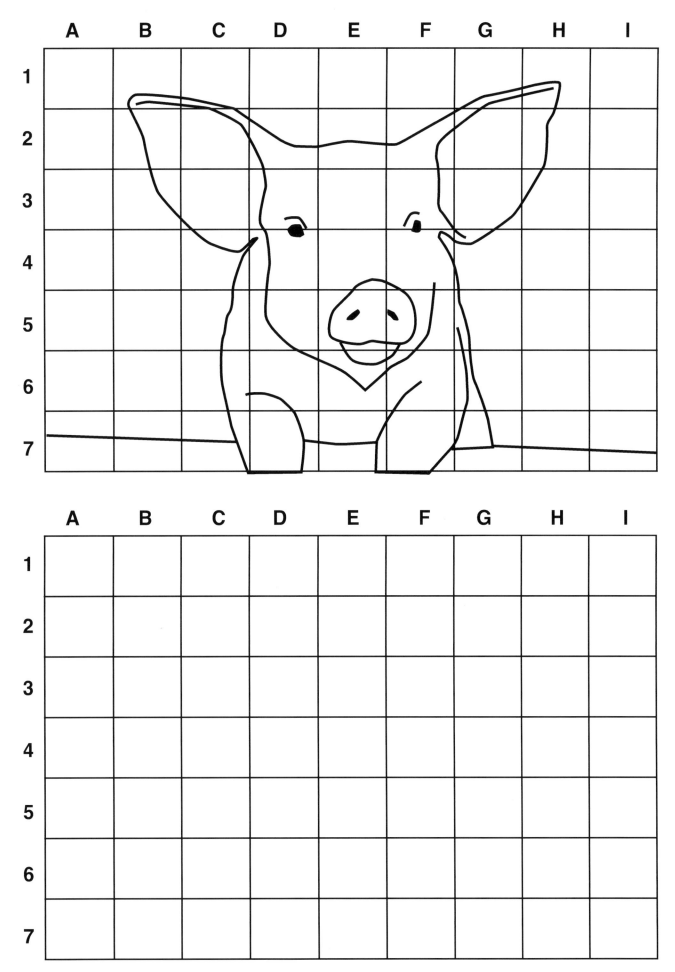

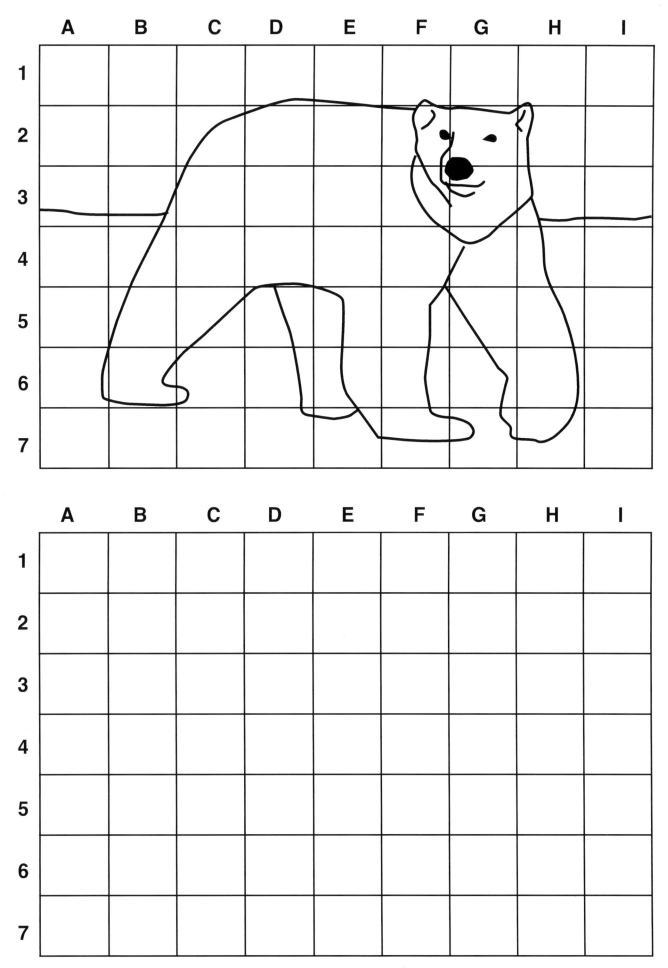

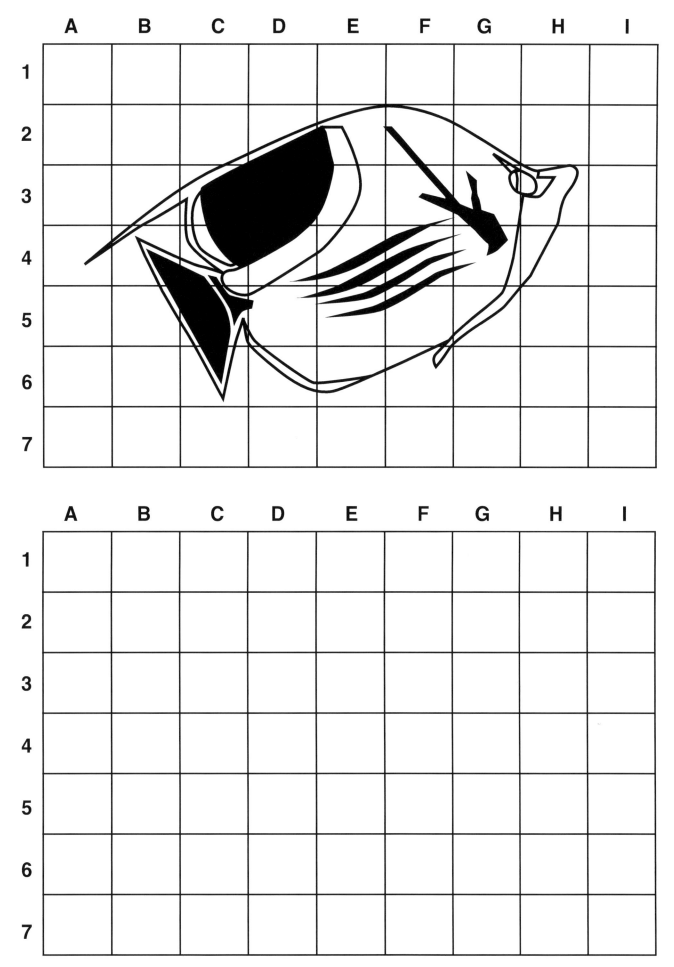

	A	B	C	D	E	F	G	H	I
1									
2									
3									
4									
5									
6									
7									

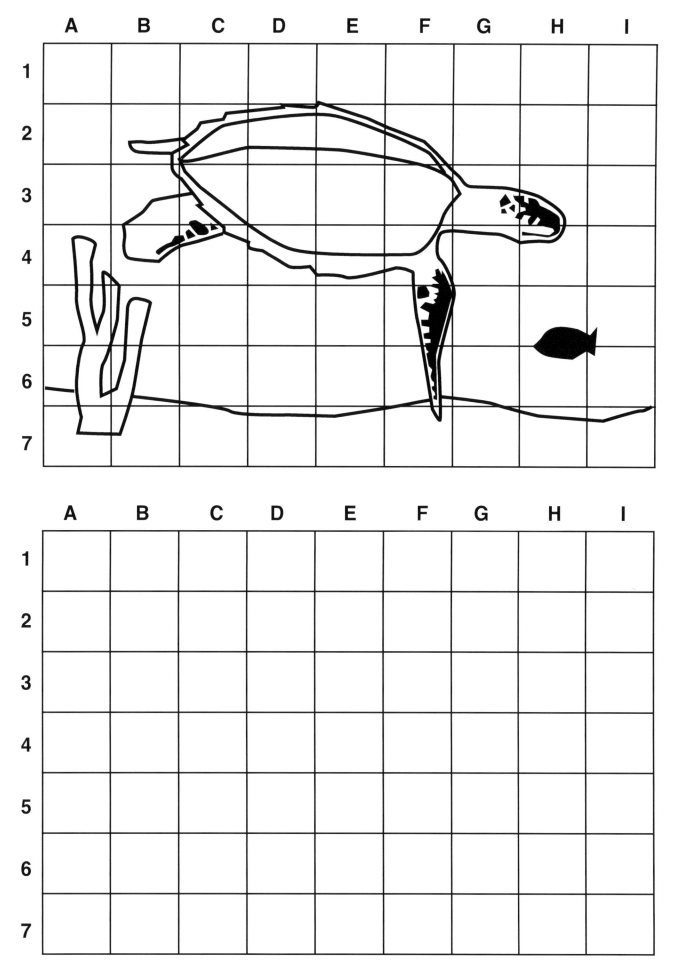

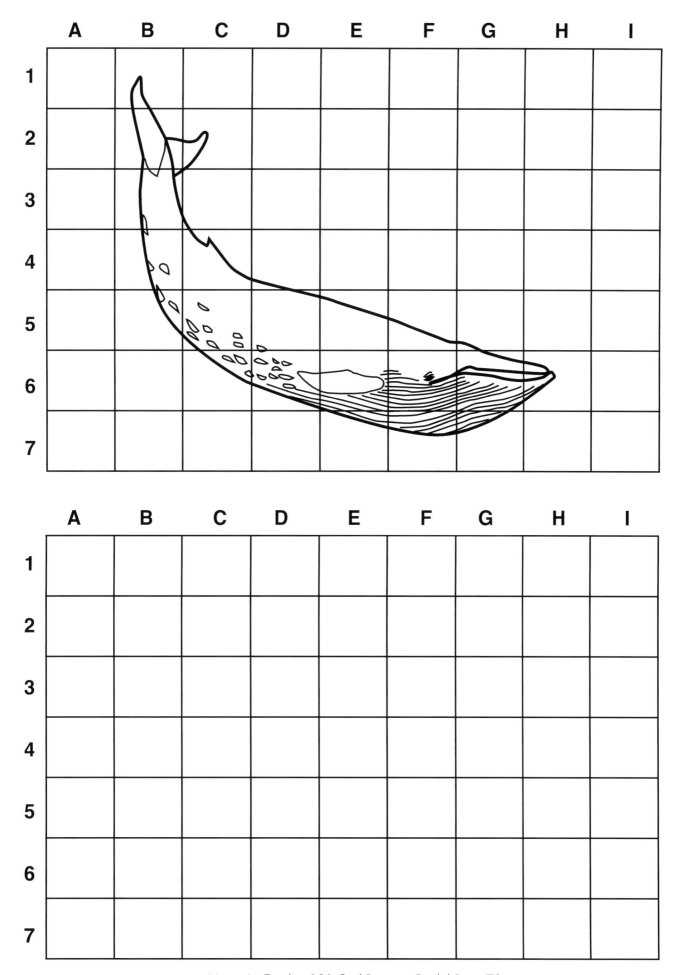

	A	B	C	D	E	F	G	H	I
1									
2									
3									
4									
5									
6									
7									

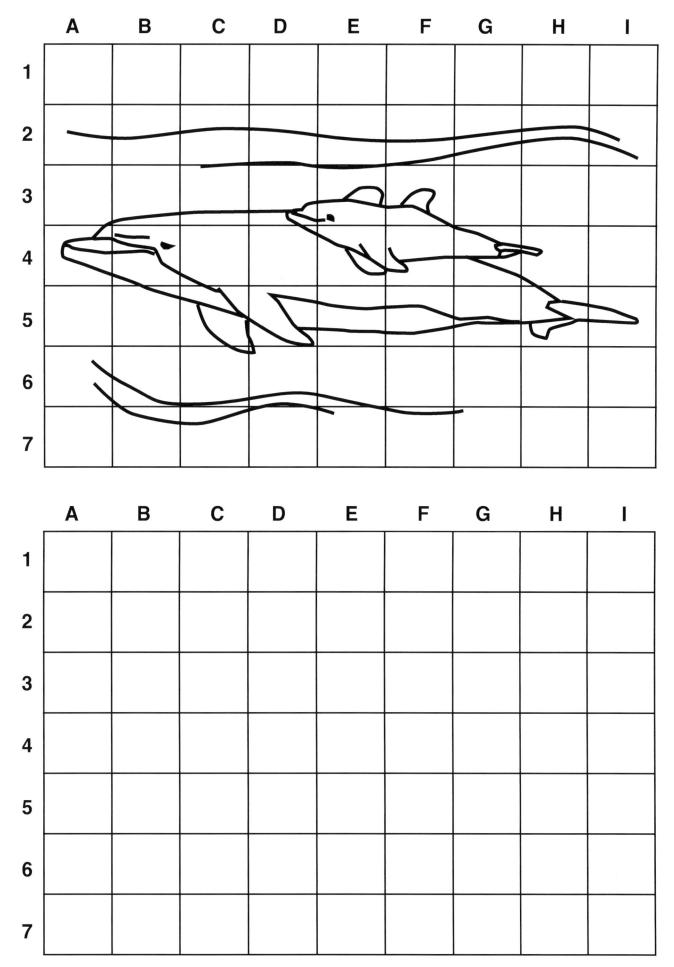

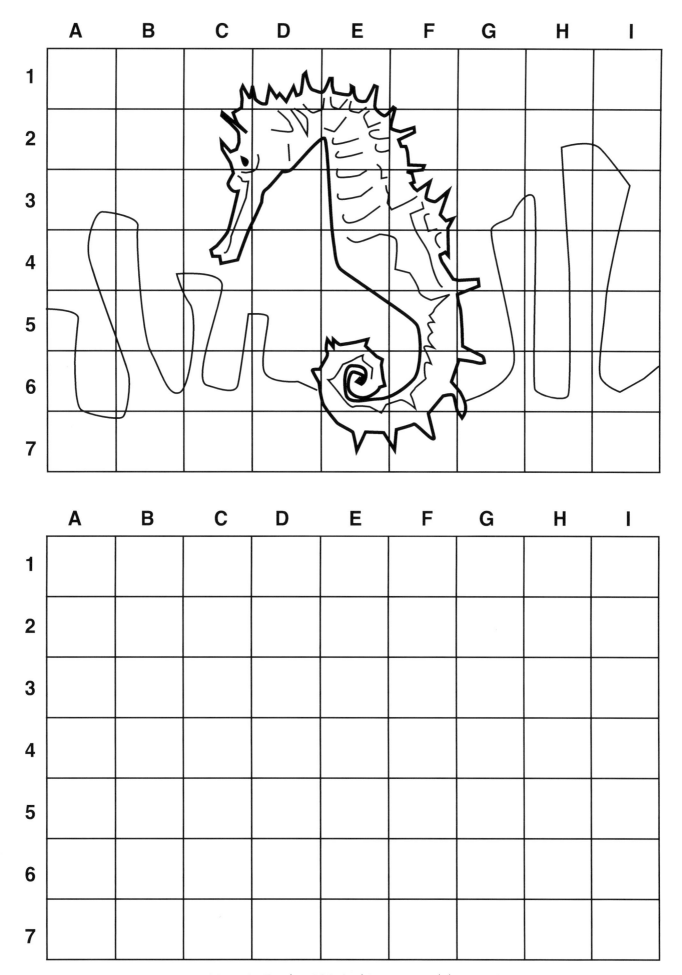

	A	B	C	D	E	F	G	H	I
1									
2									
3									
4									
5									
6									
7									

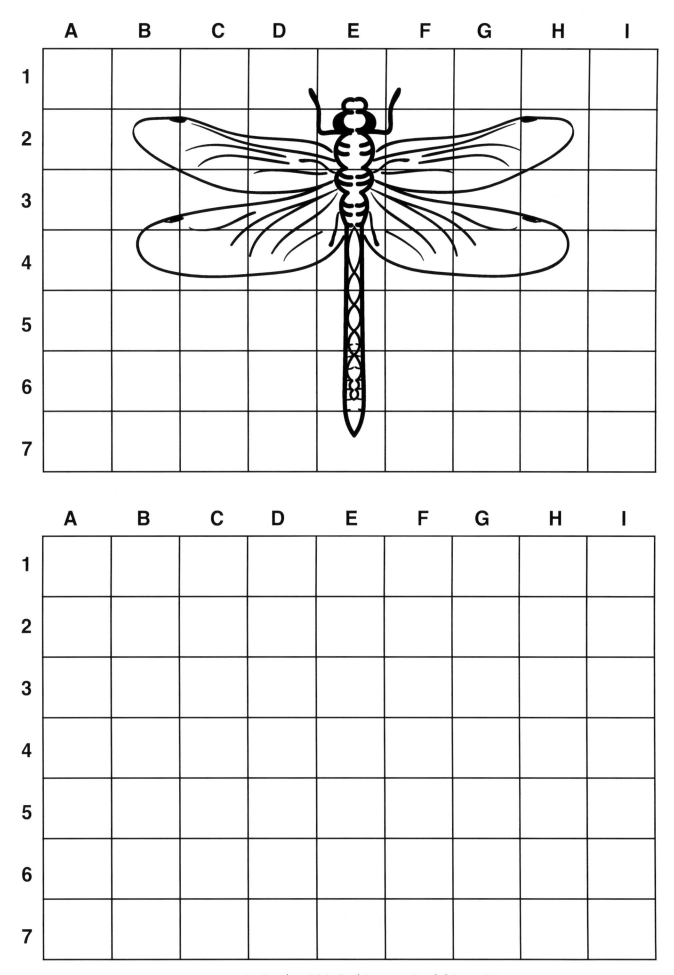

	A	B	C	D	E	F	G	H	I
1									
2									
3									
4									
5									
6									
7									

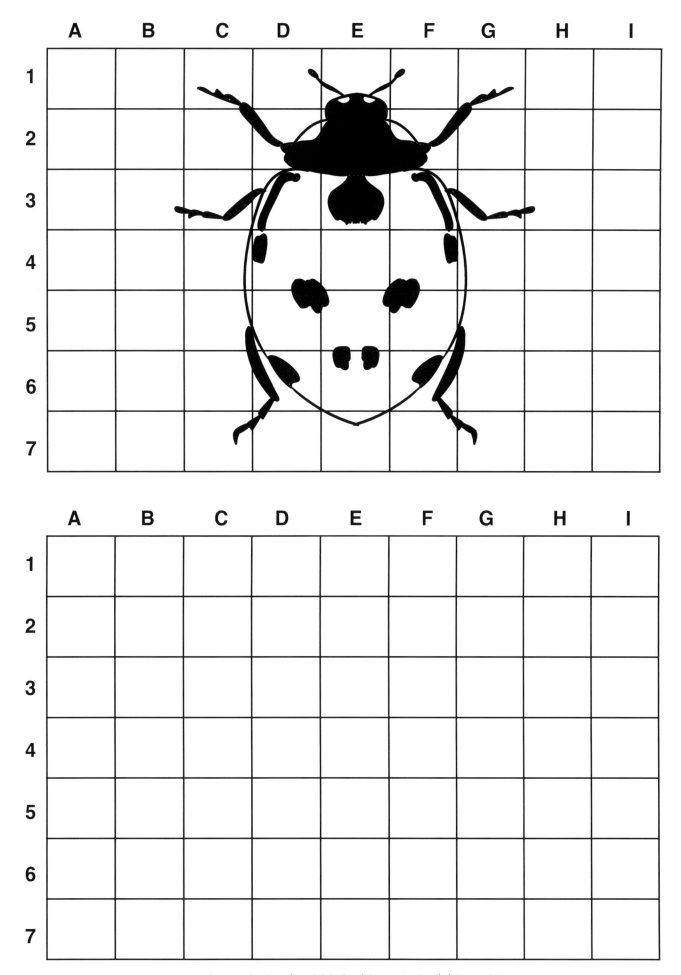

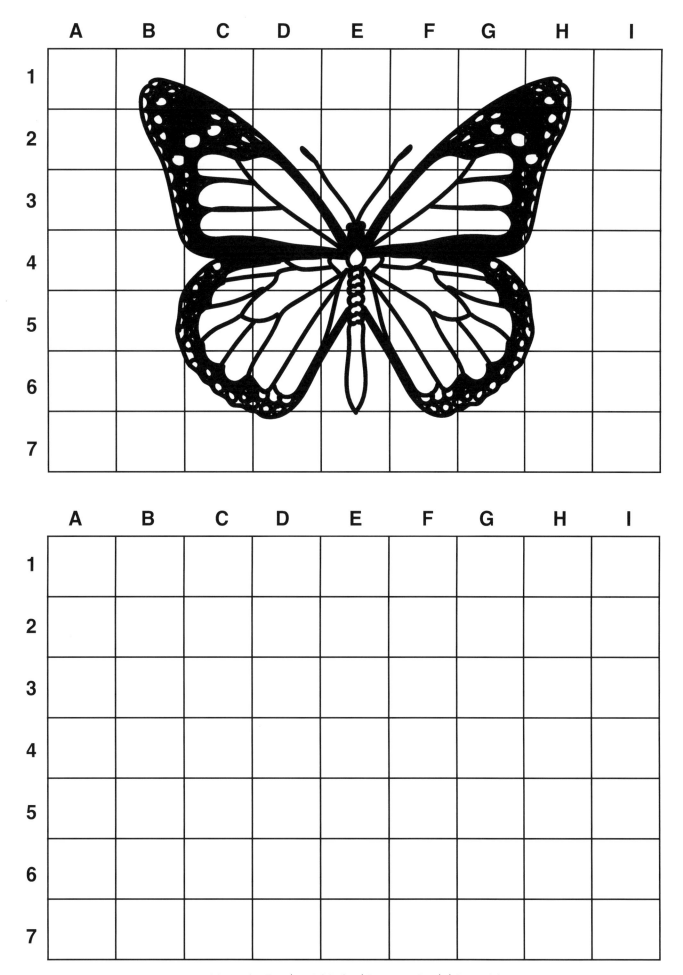

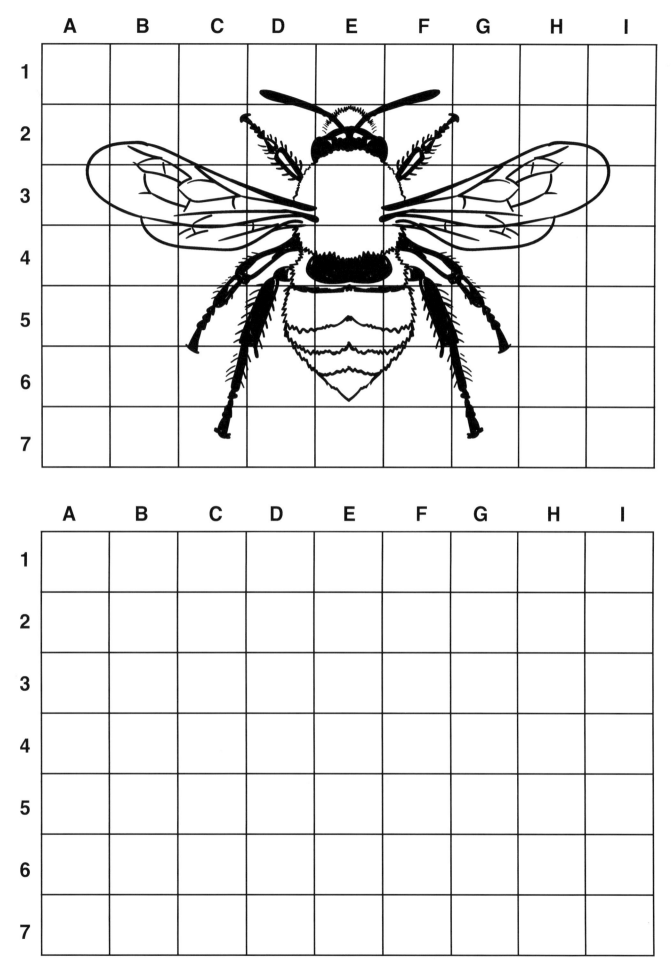

	A	B	C	D	E	F	G	H	I
1									
2									
3									
4									
5									
6									
7									

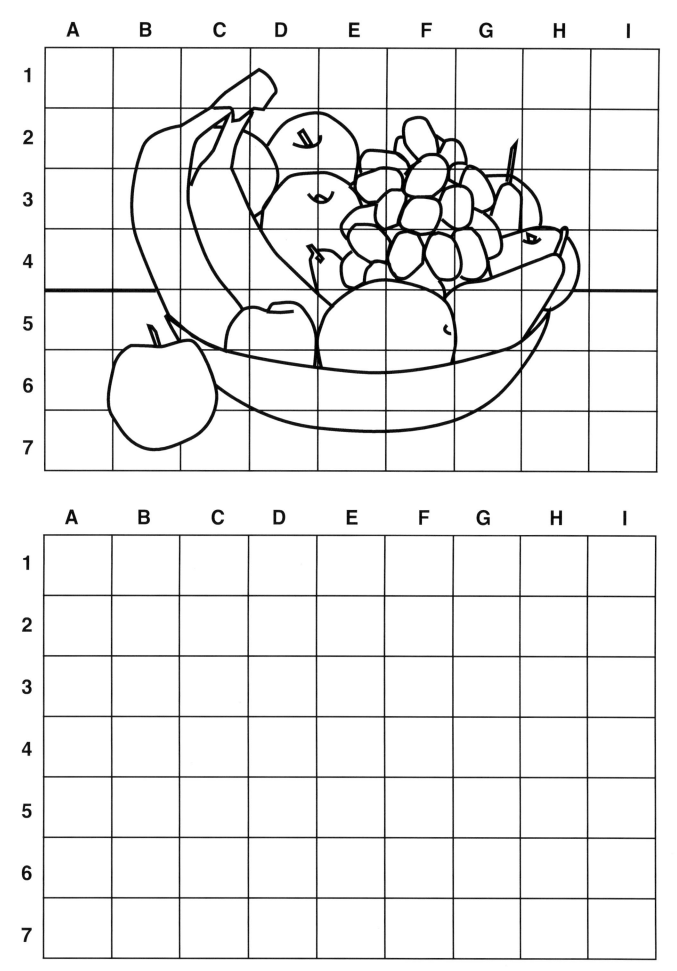

	A	B	C	D	E	F	G	H	I
1									
2									
3									
4									
5									
6									
7									

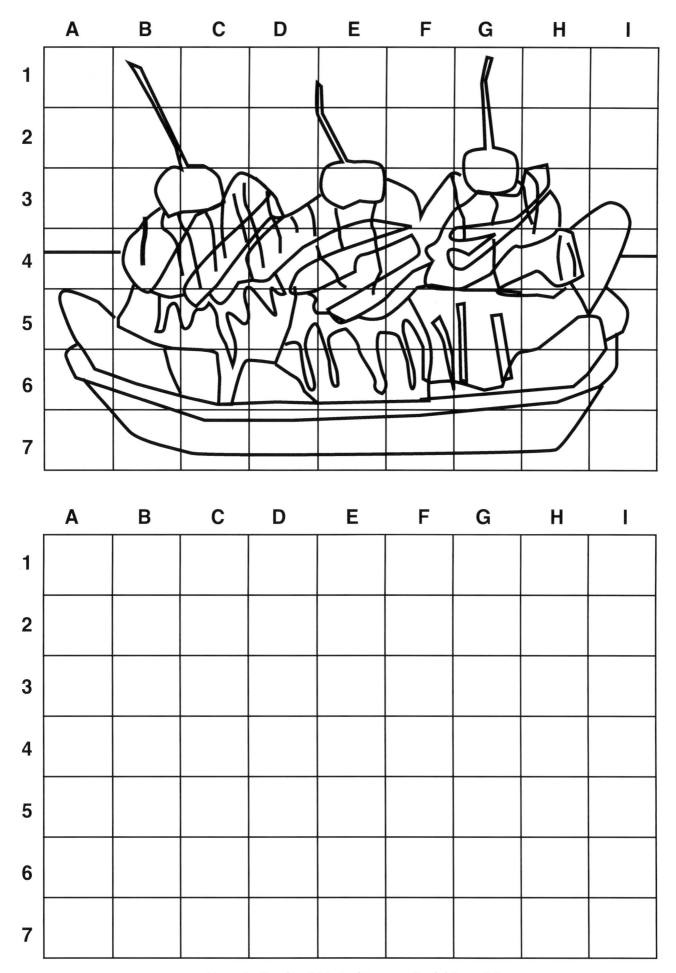

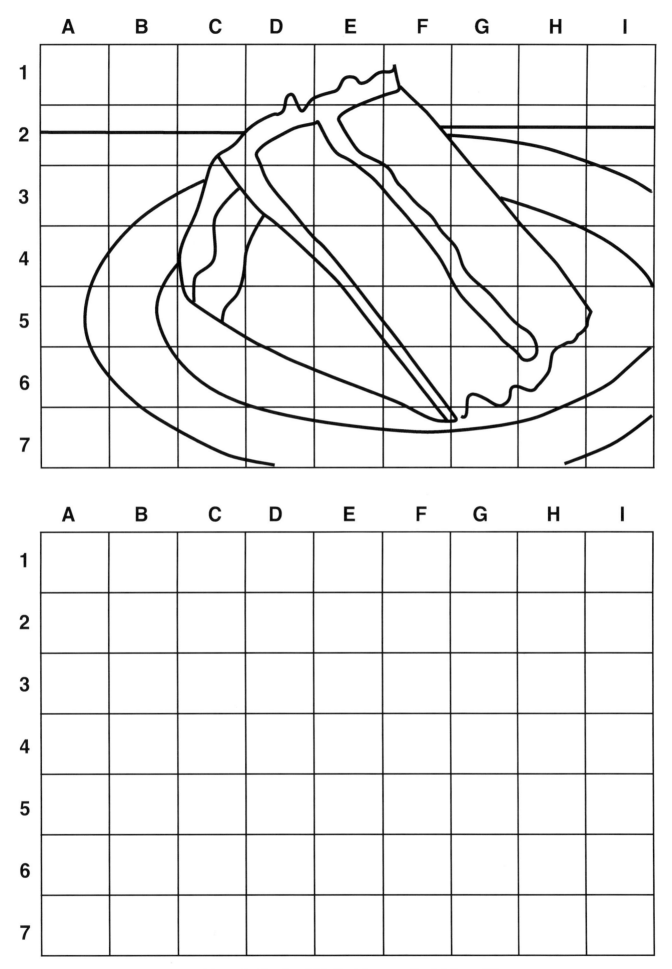

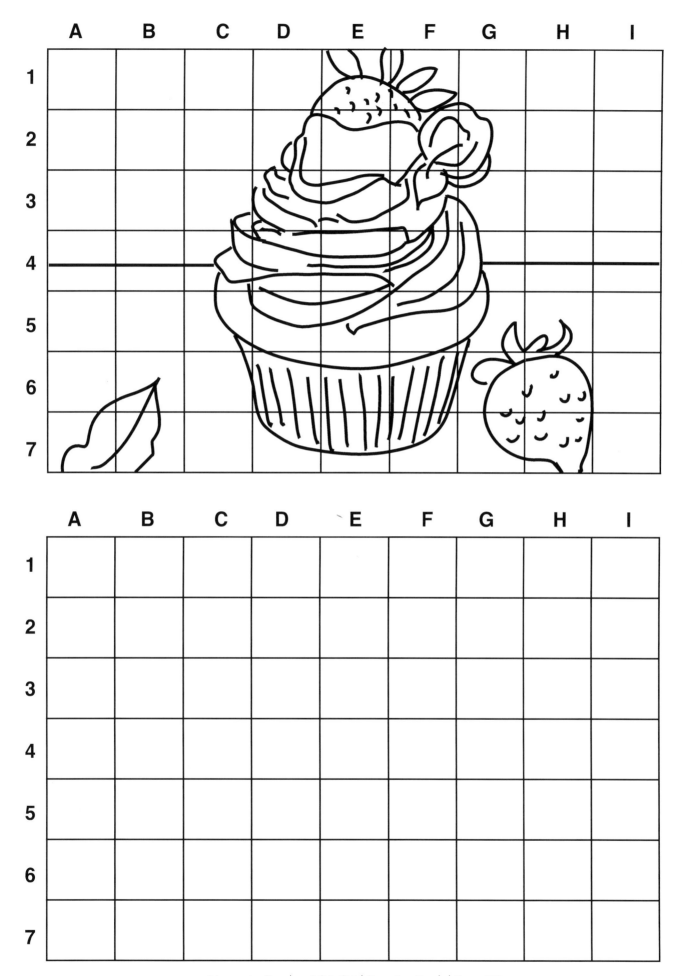

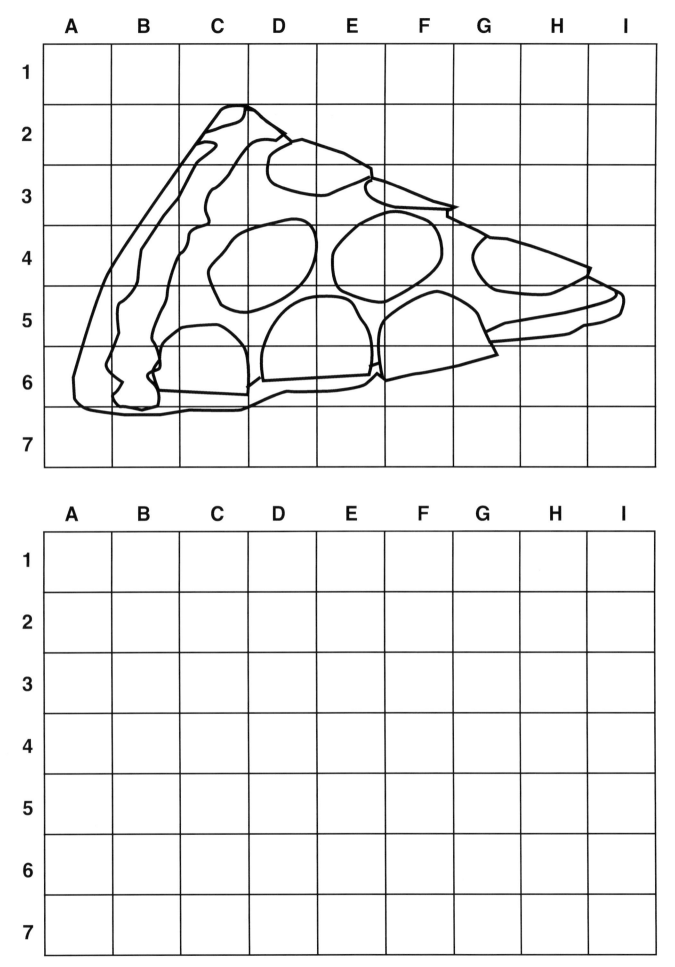

	A	B	C	D	E	F	G	H	I
1									
2									
3									
4									
5									
6									
7									

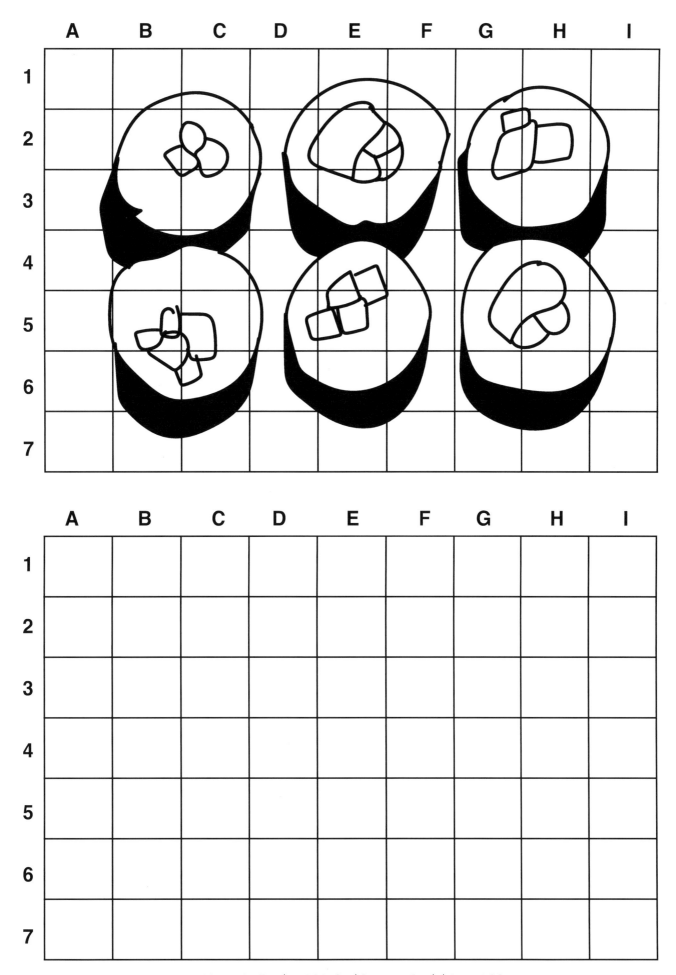

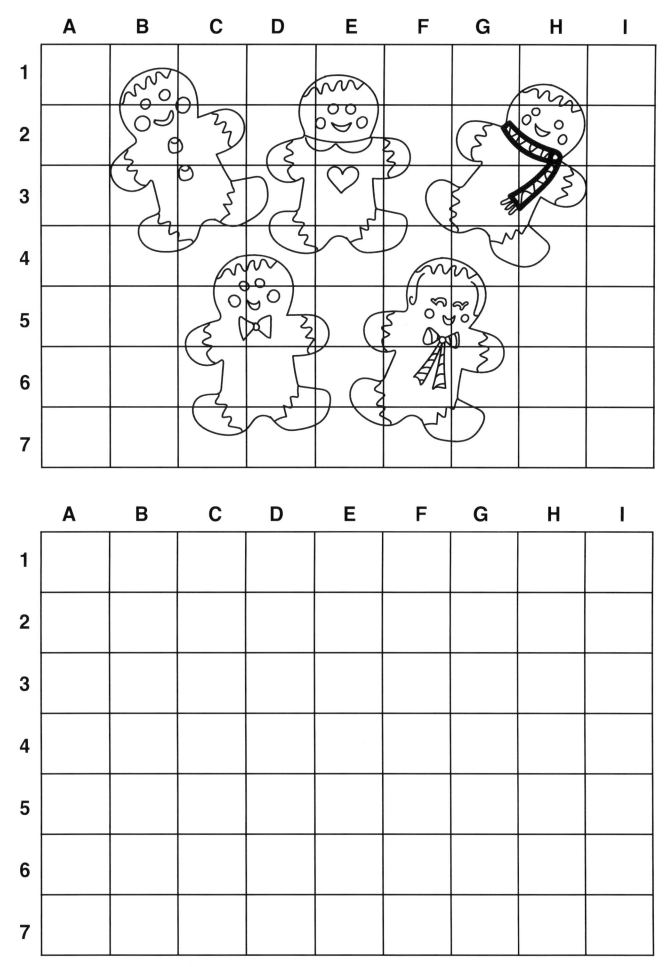

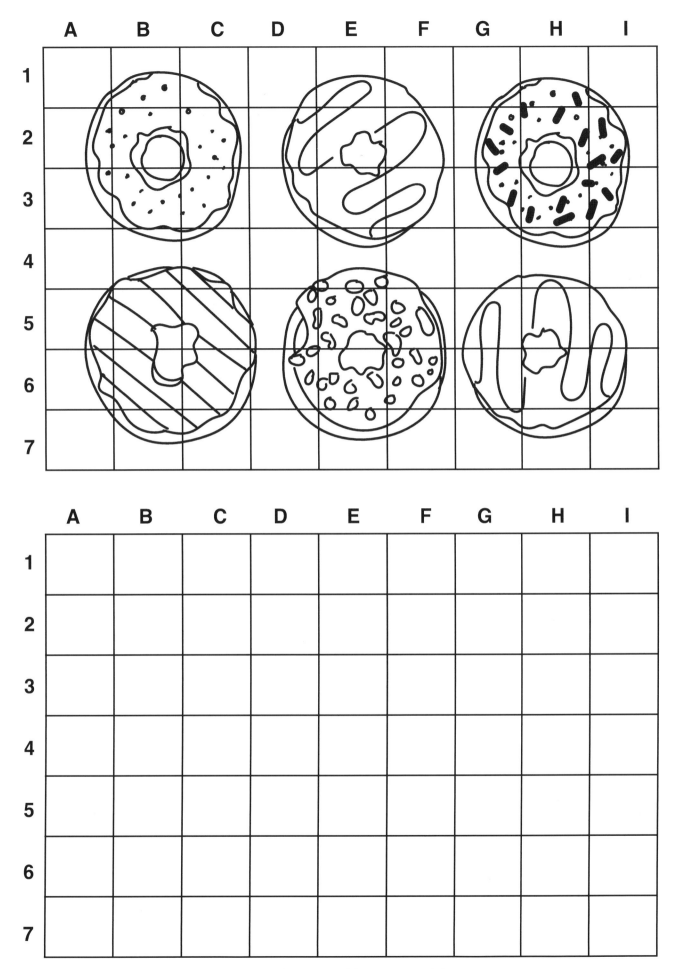

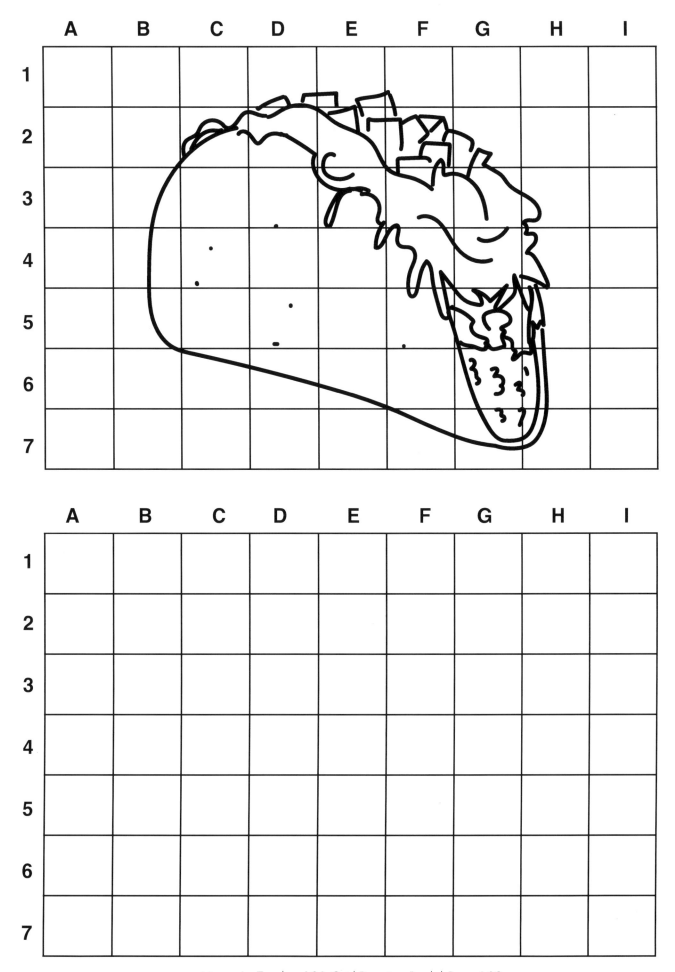

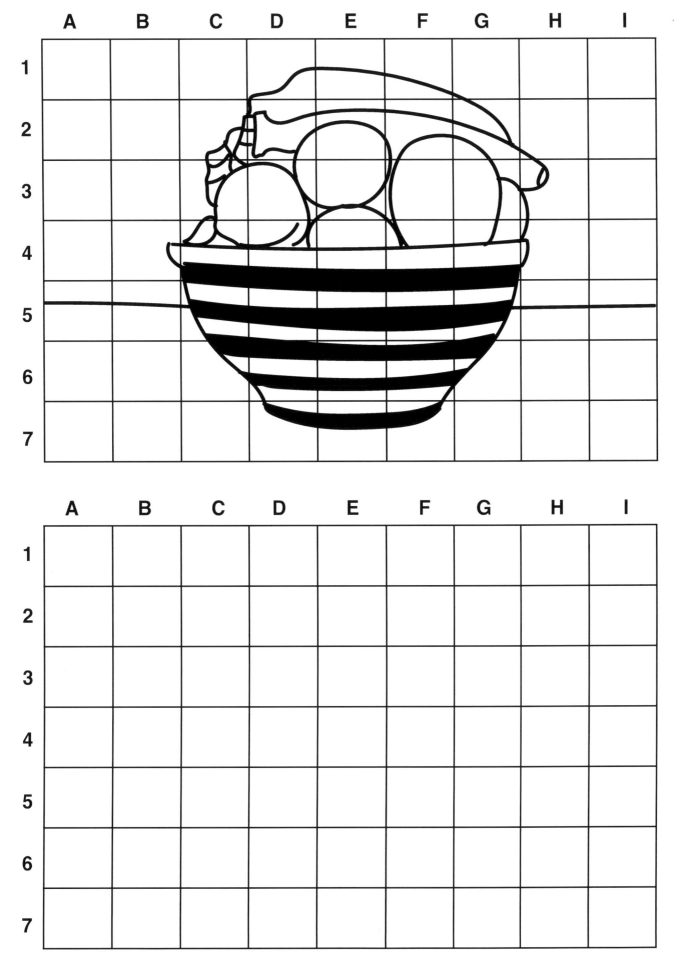

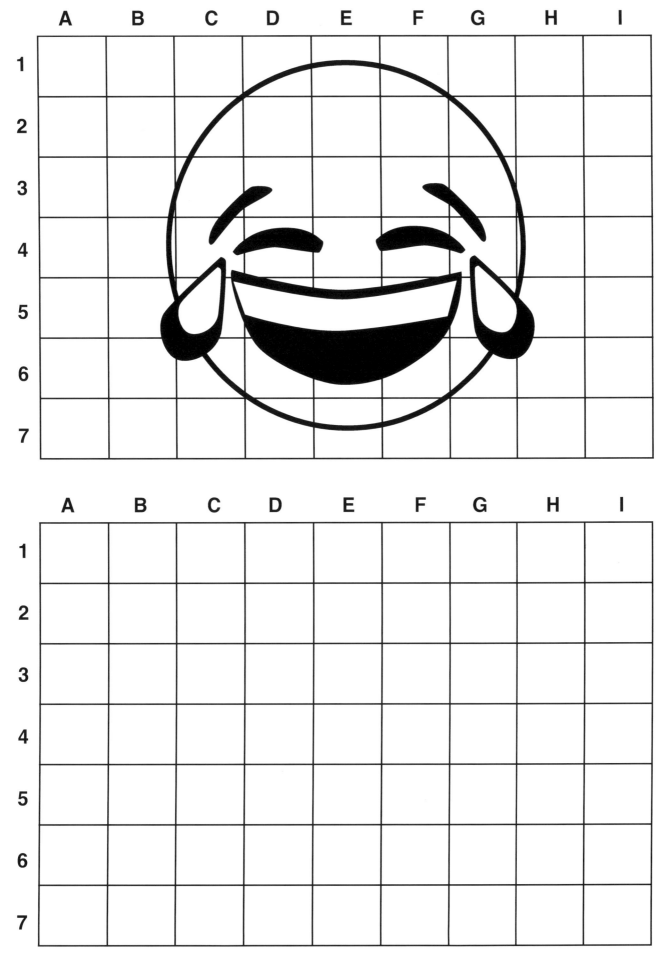

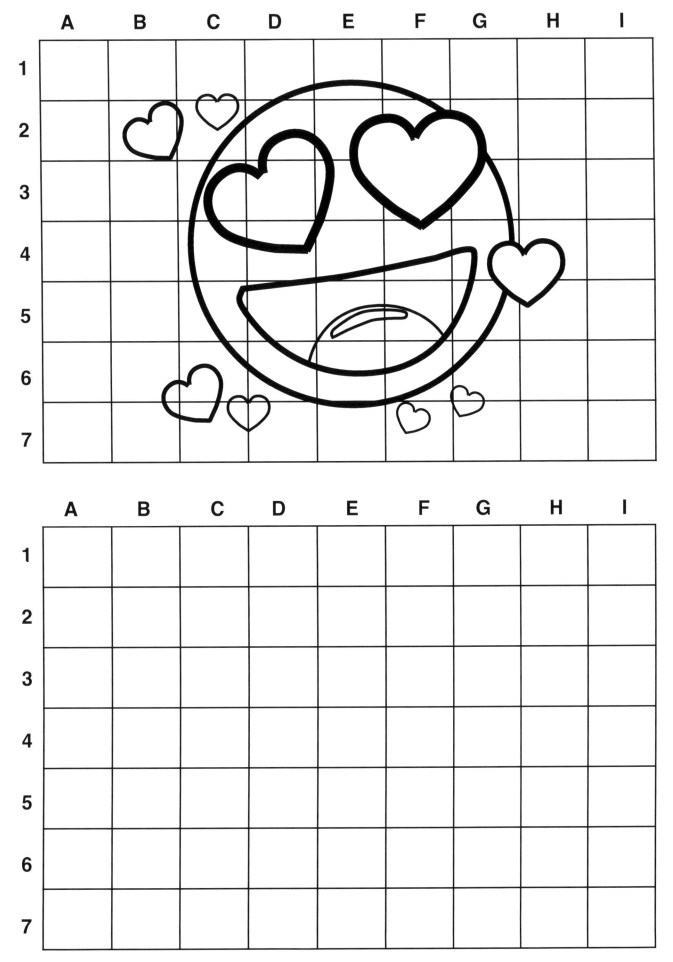

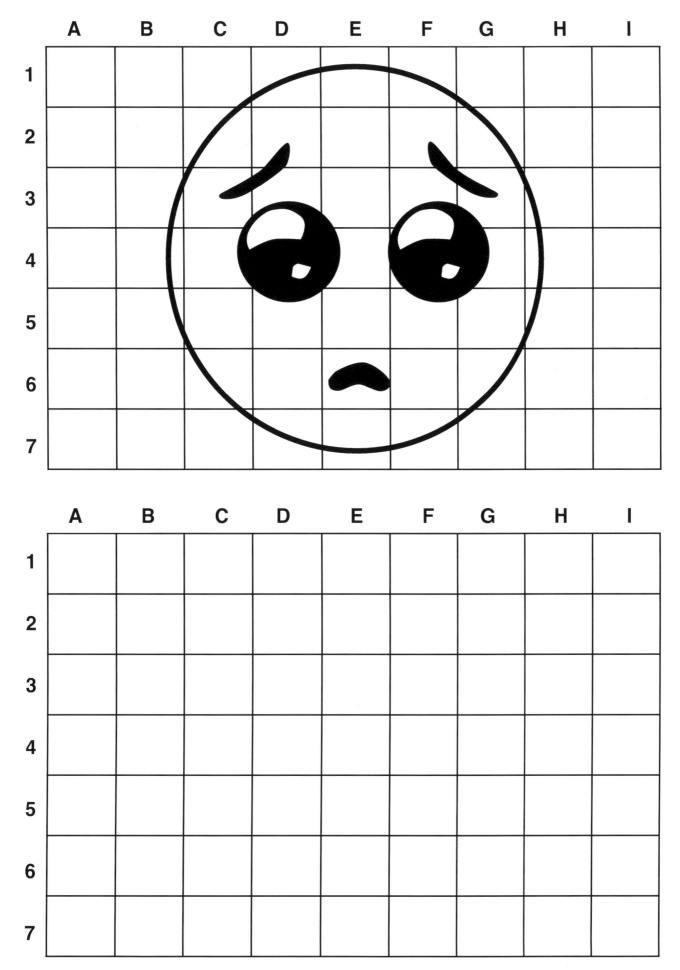

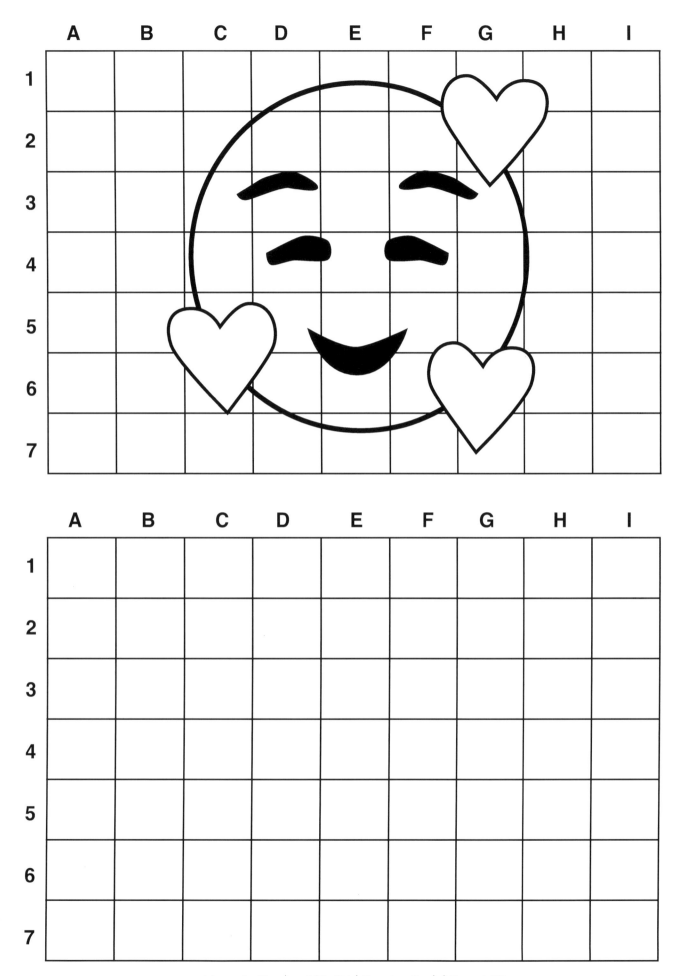

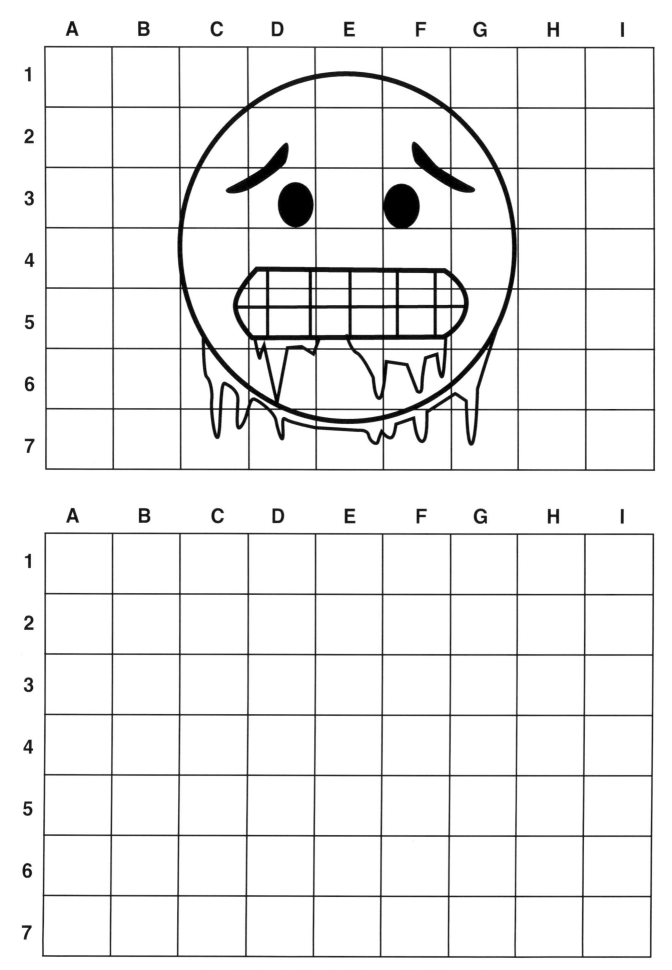

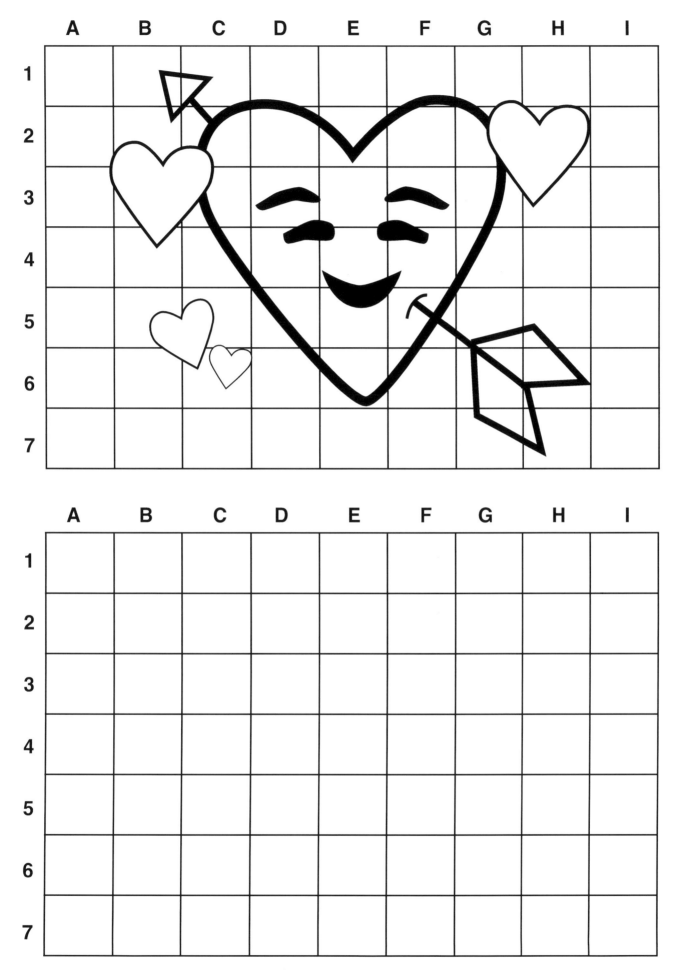

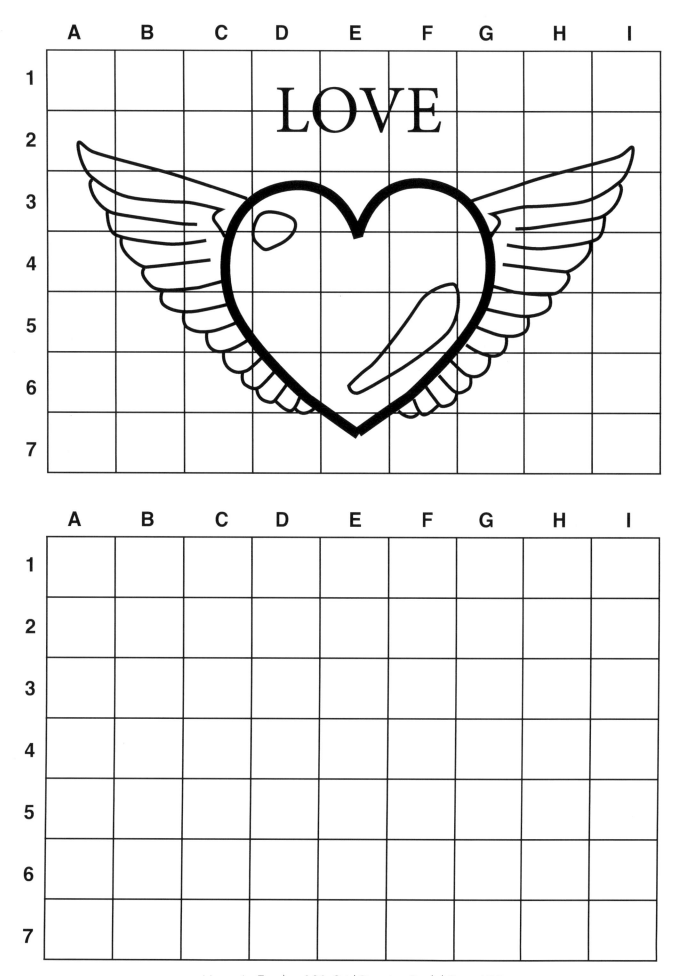

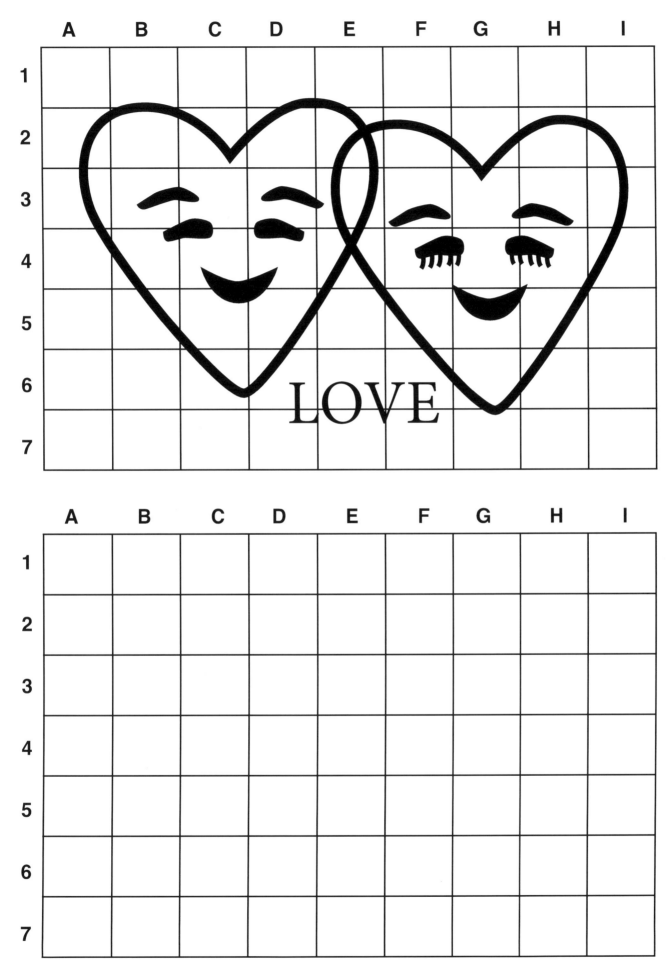

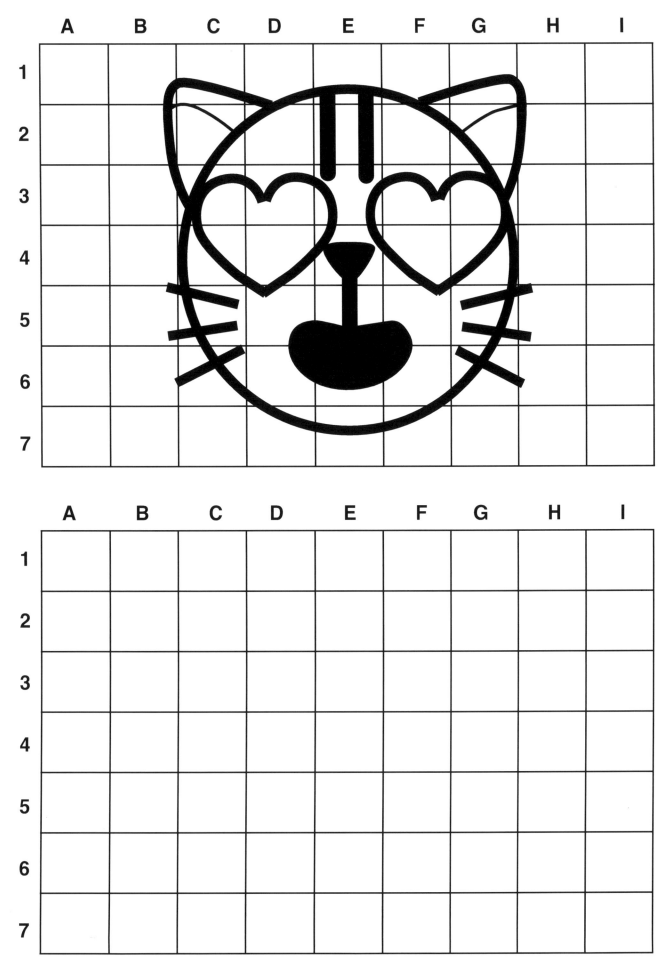

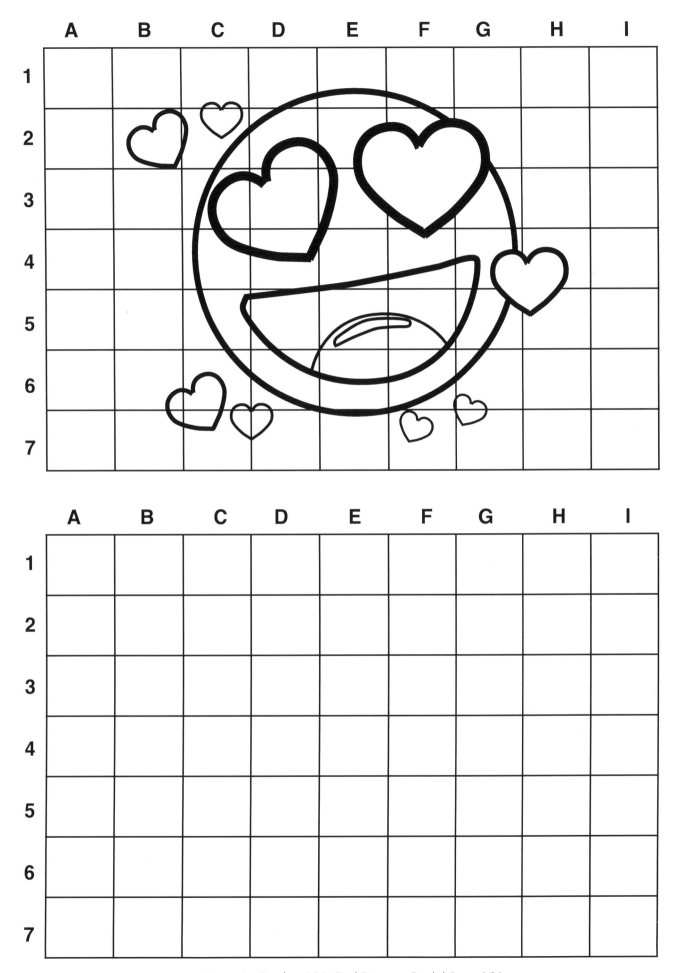

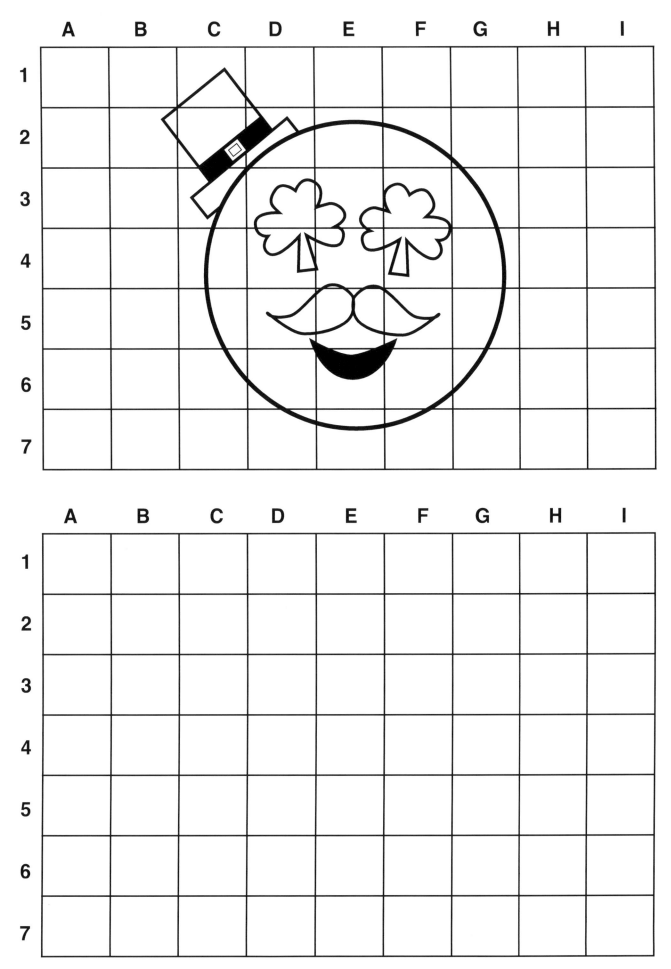

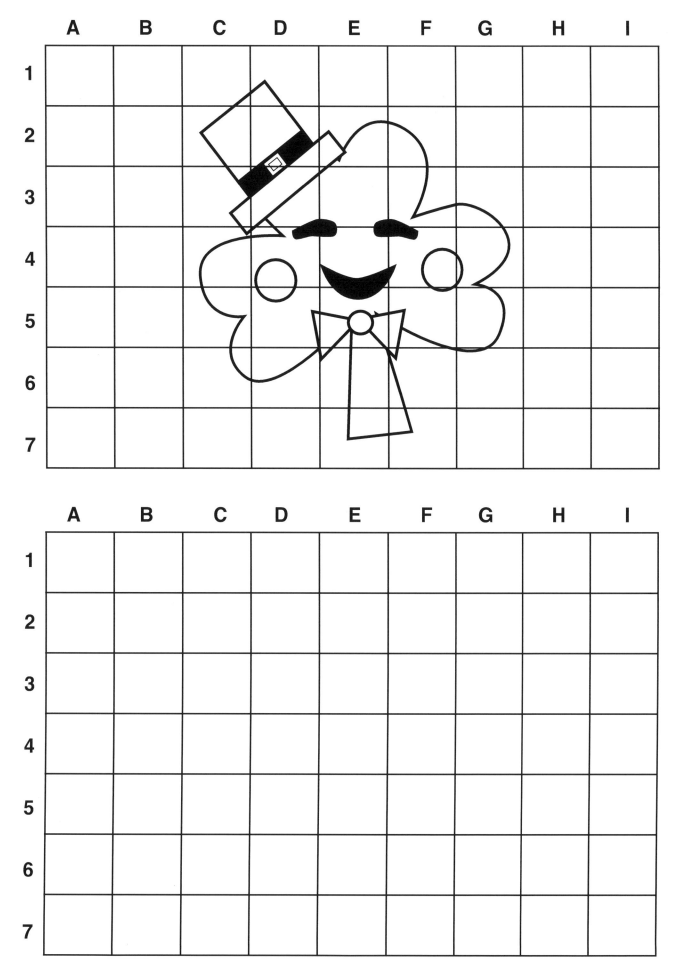

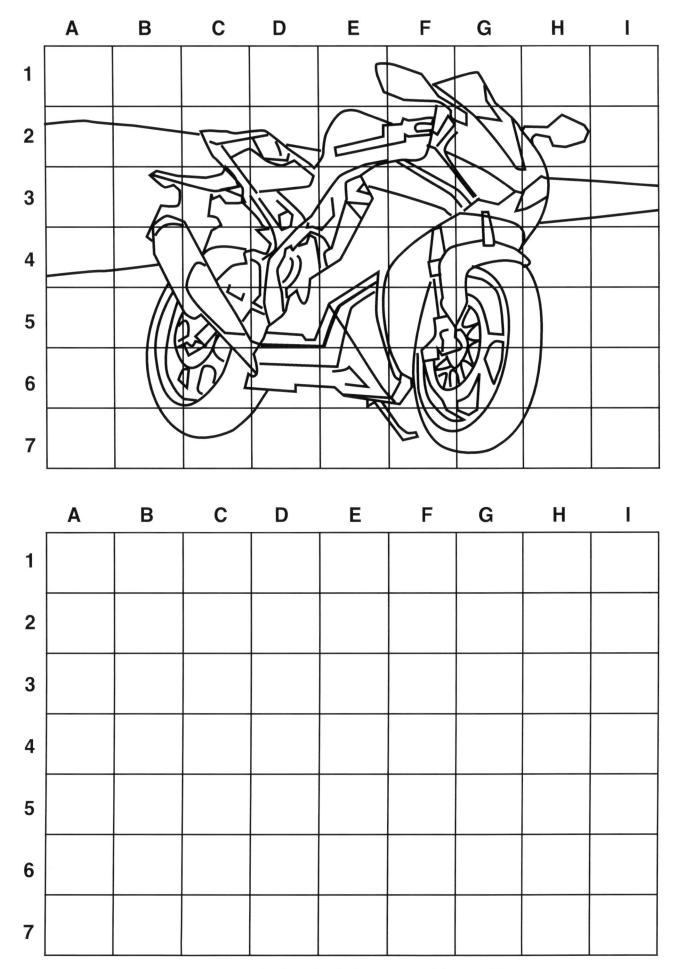

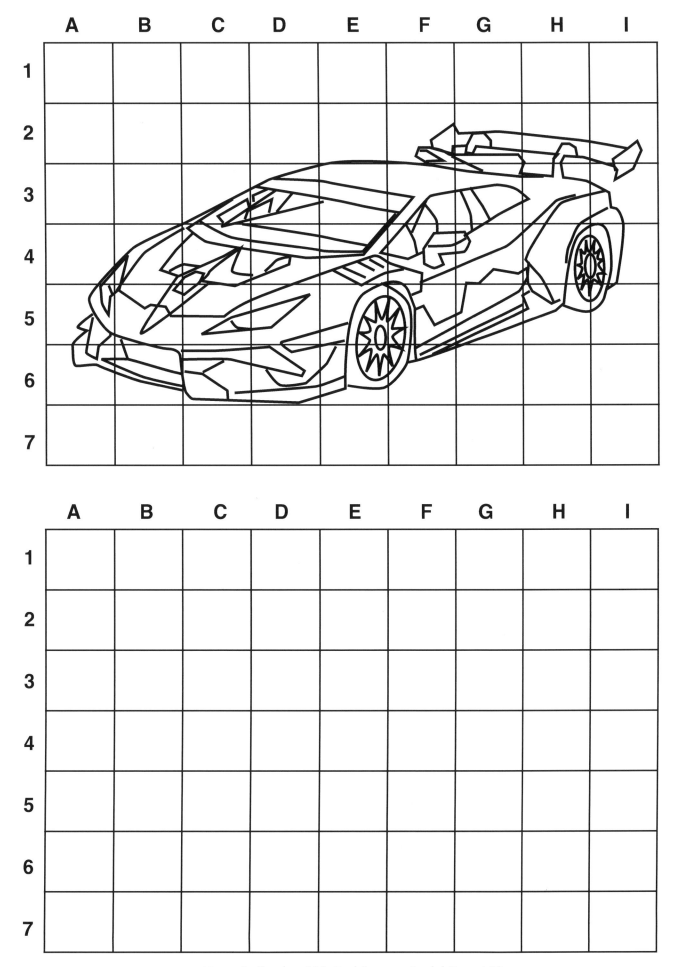

	A	B	C	D	E	F	G	H	I
1									
2									
3									
4									
5									
6									
7									

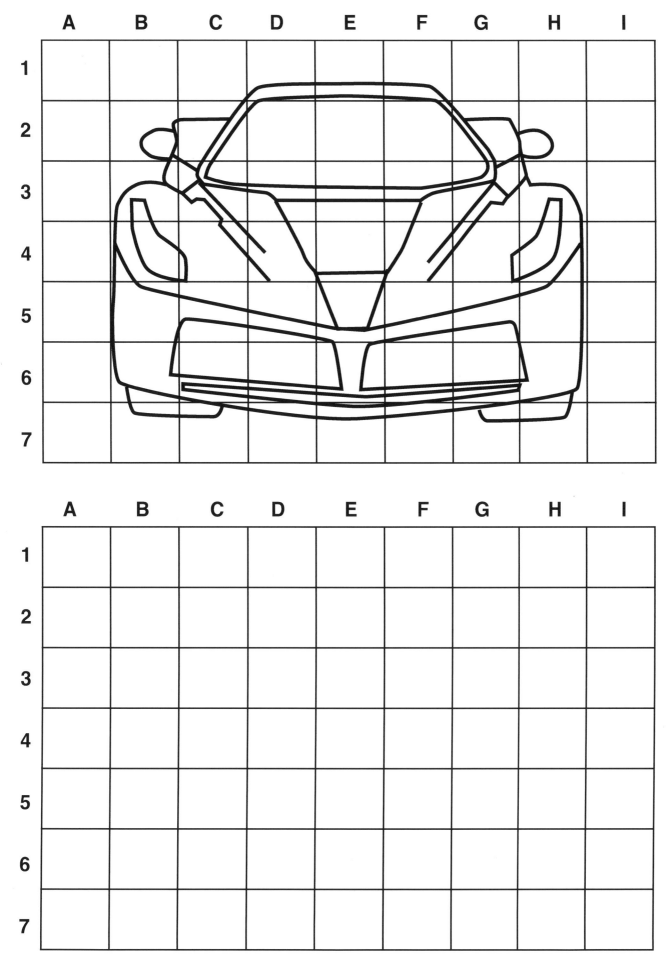

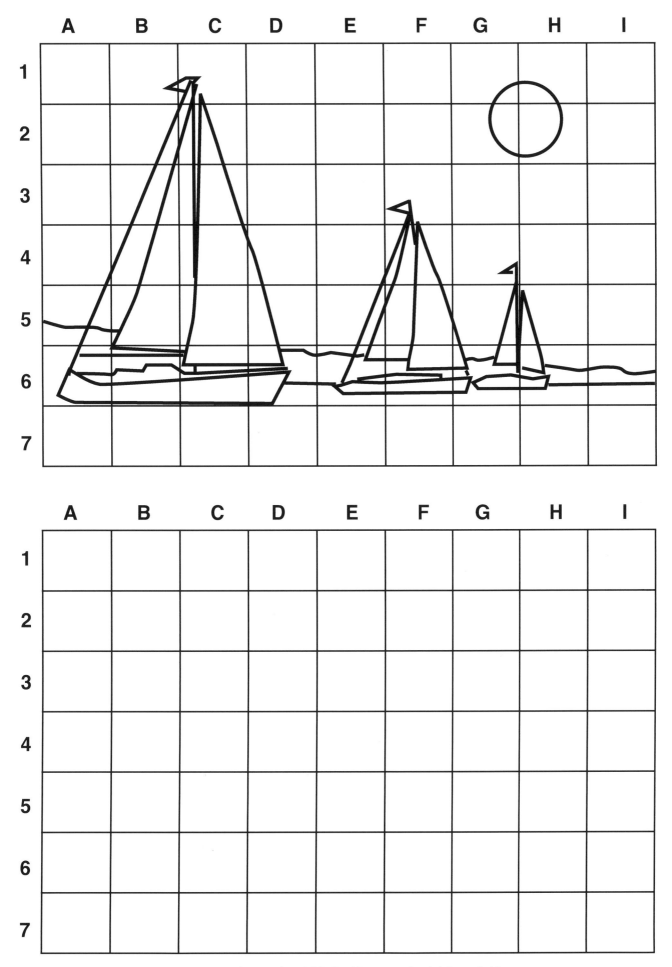

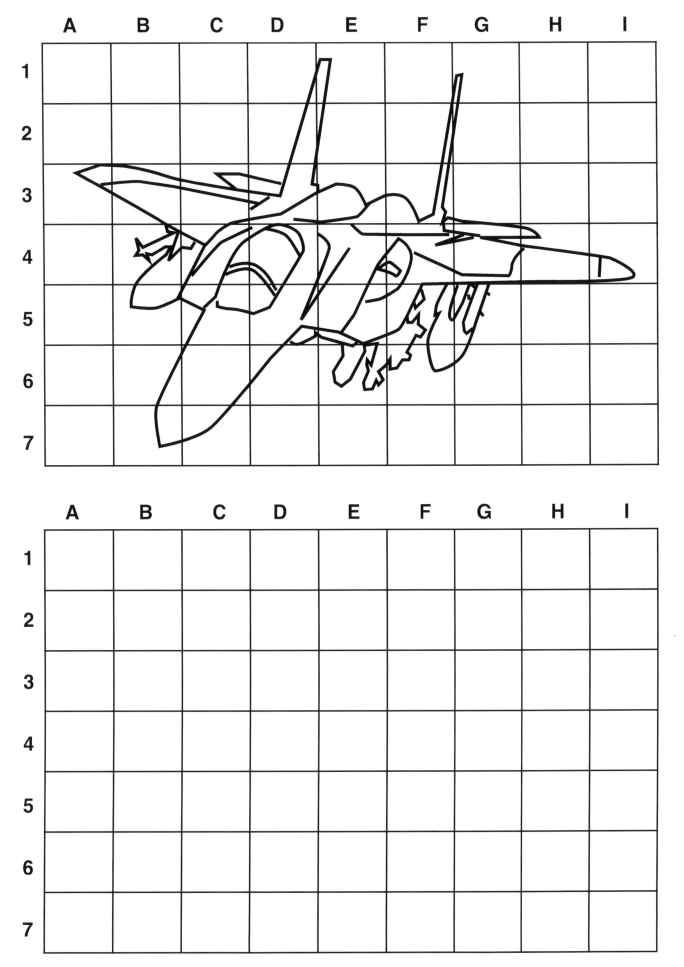

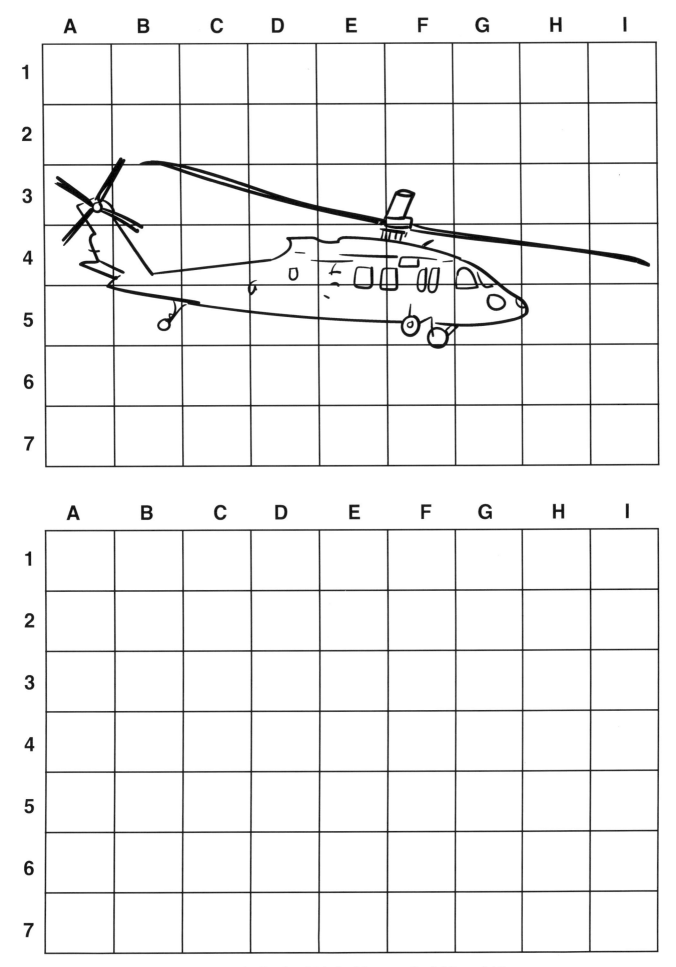

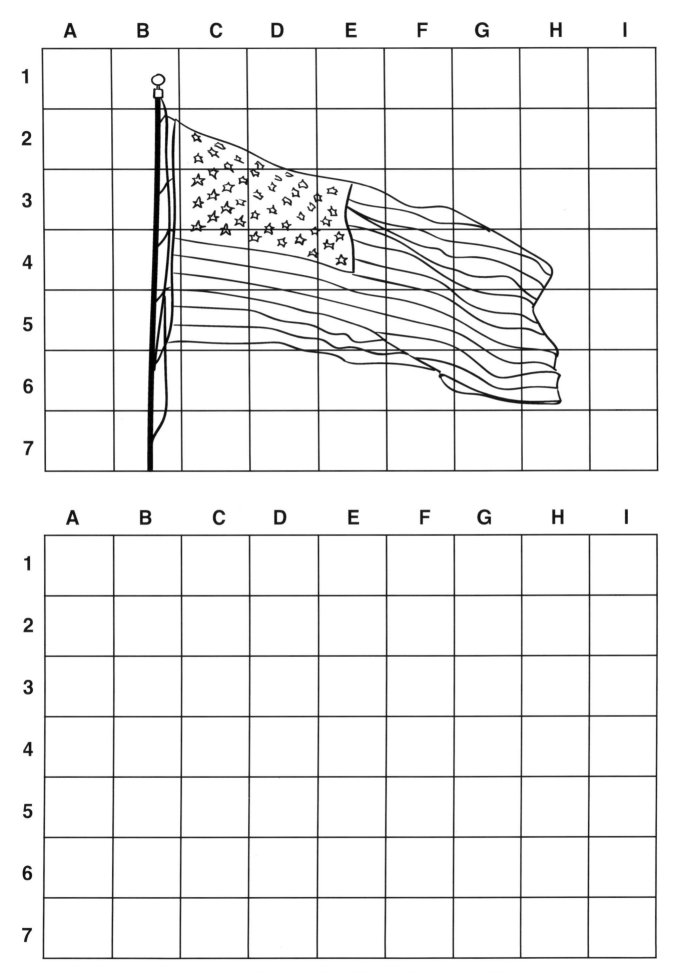

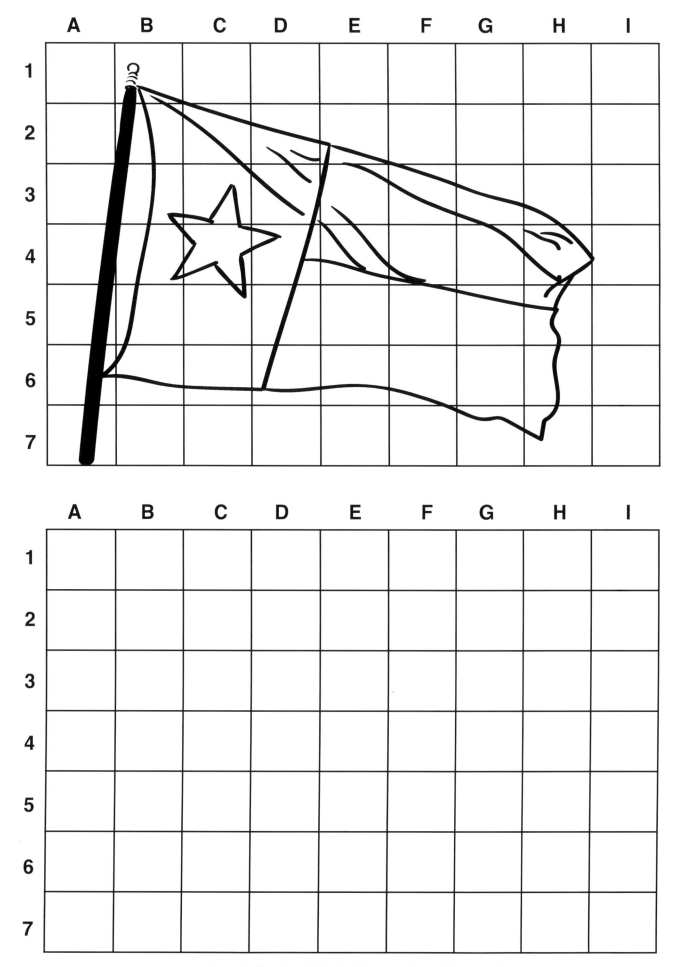

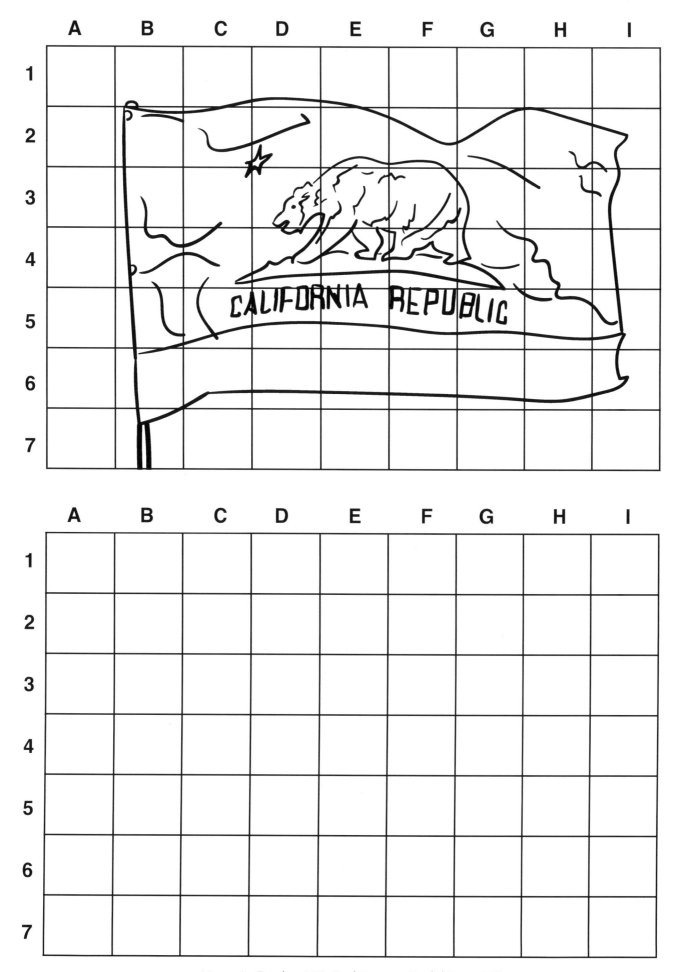

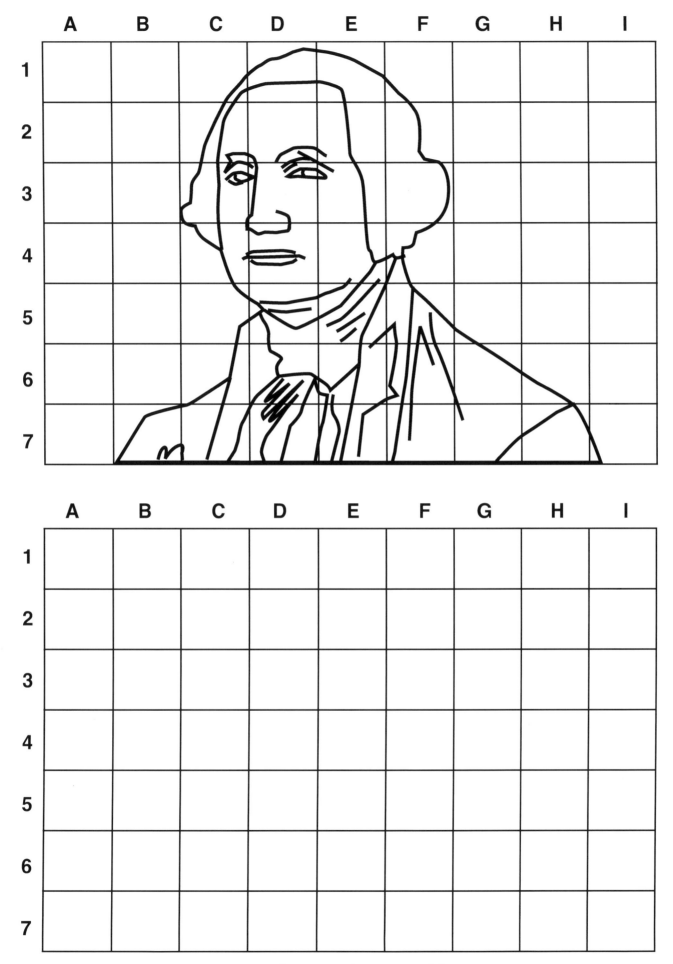

	A	B	C	D	E	F	G	H	I
1									
2									
3									
4									
5									
6									
7									

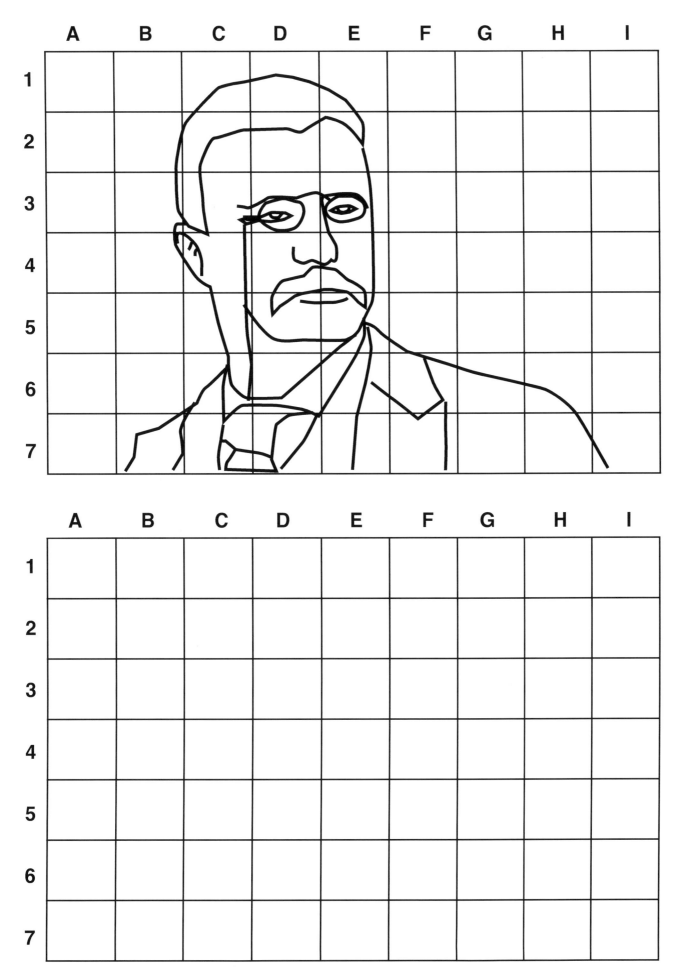

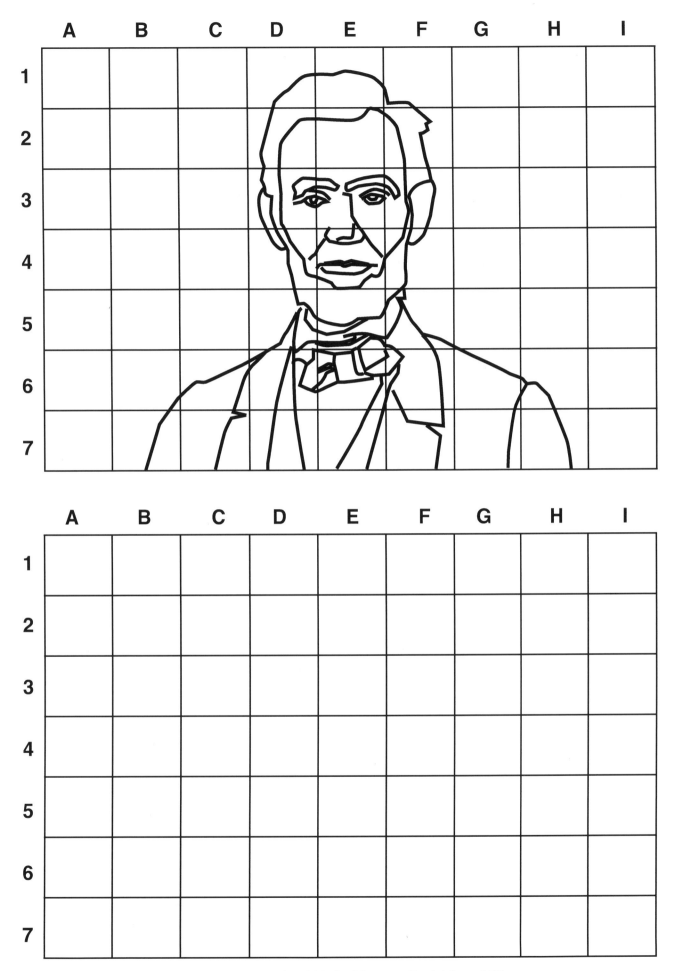

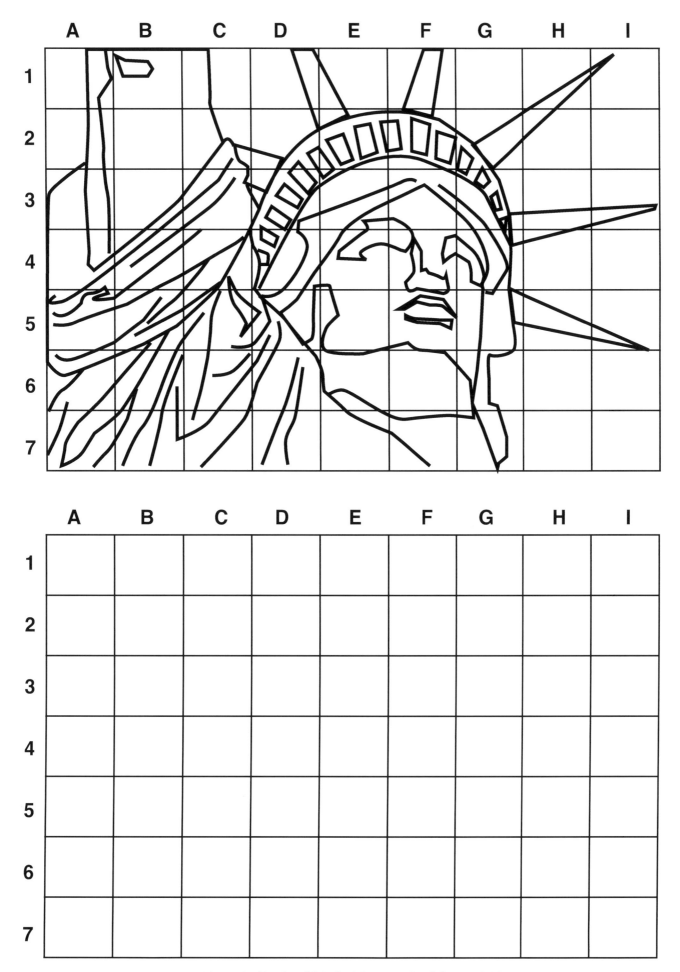

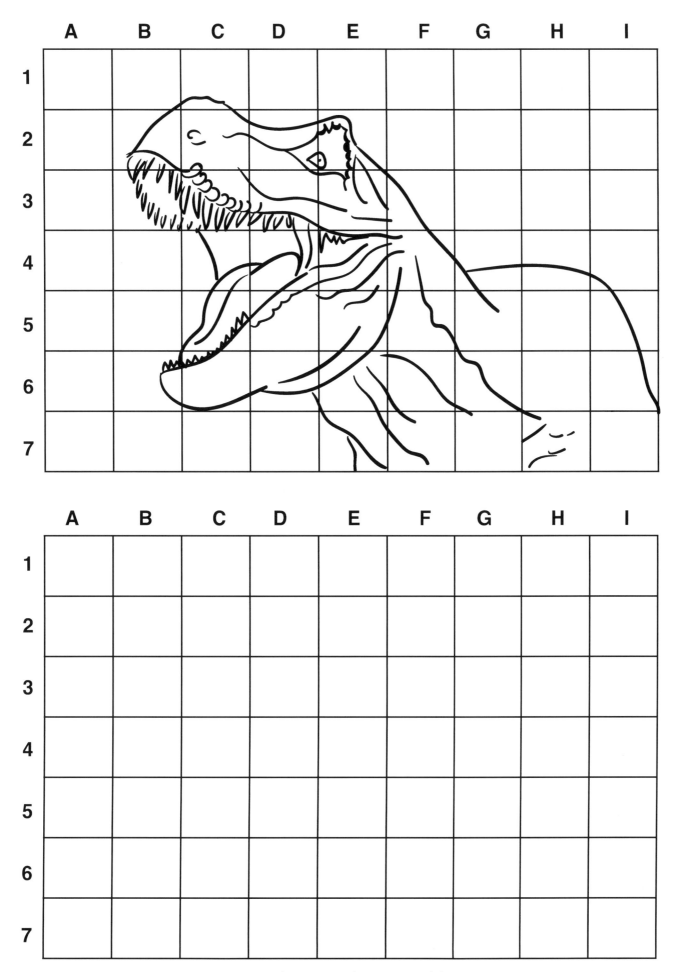

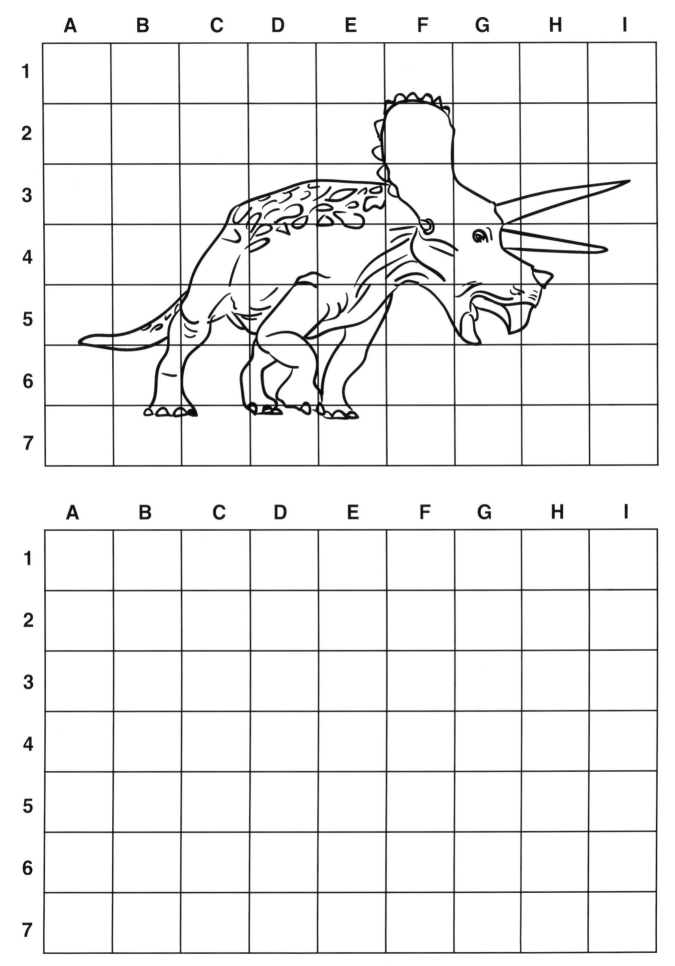

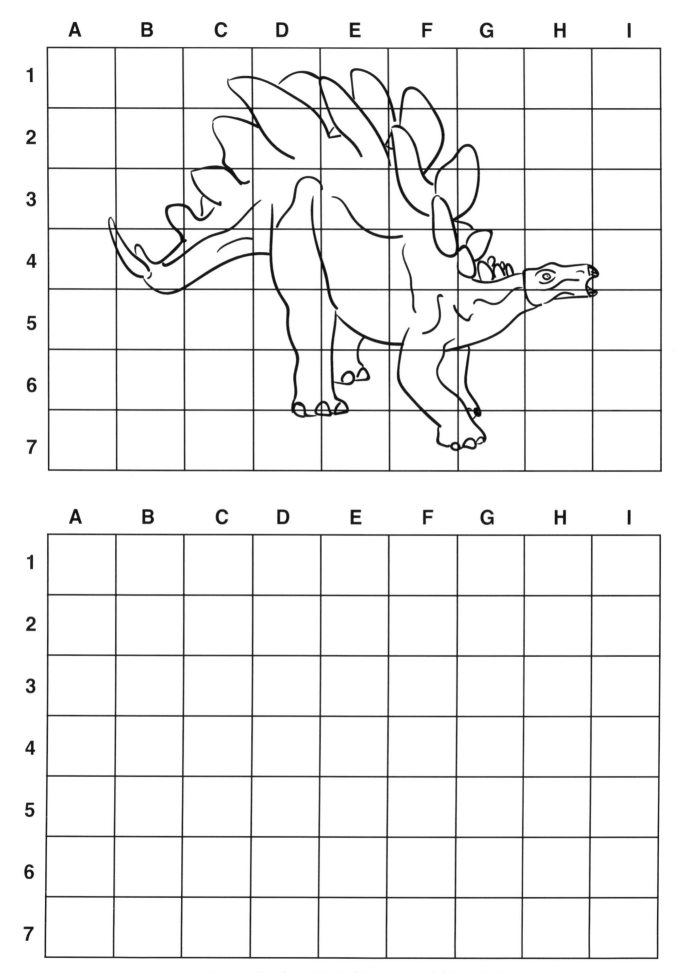

	A	B	C	D	E	F	G	H	I
1									
2									
3									
4									
5									
6									
7									

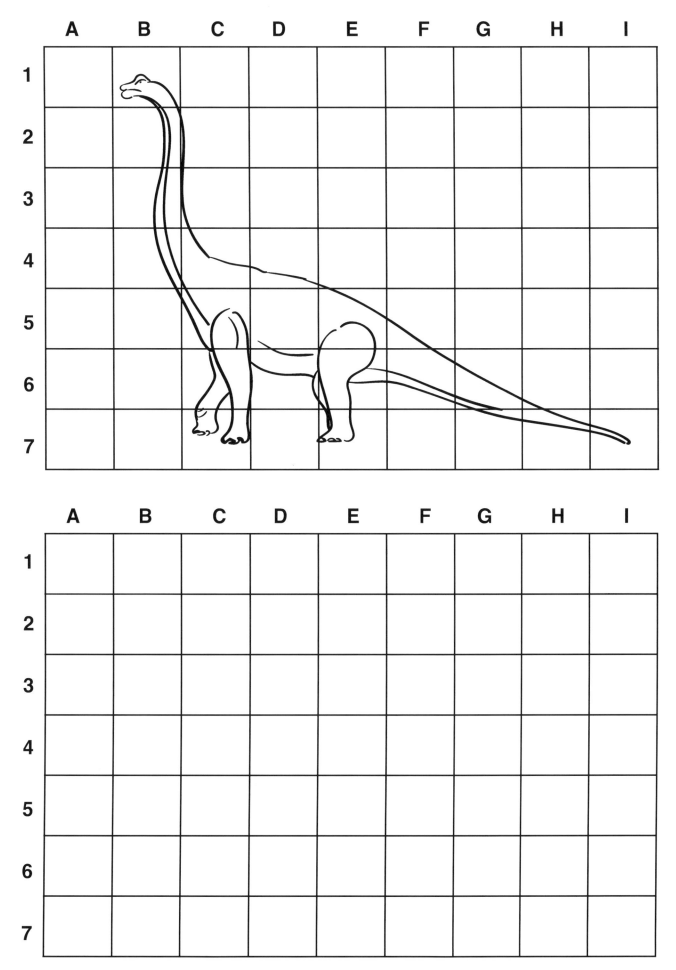

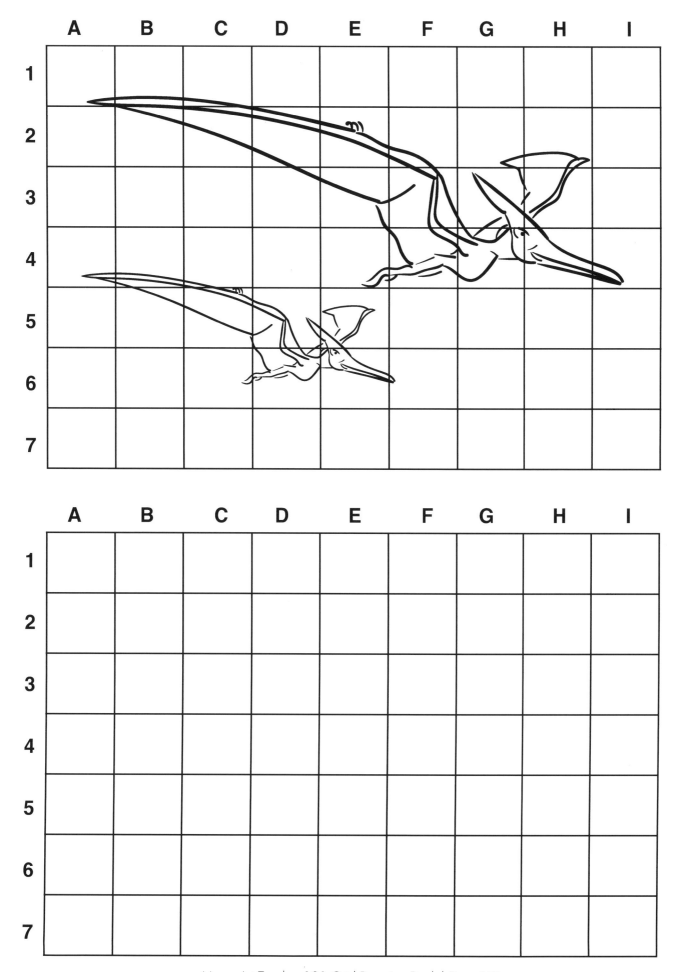

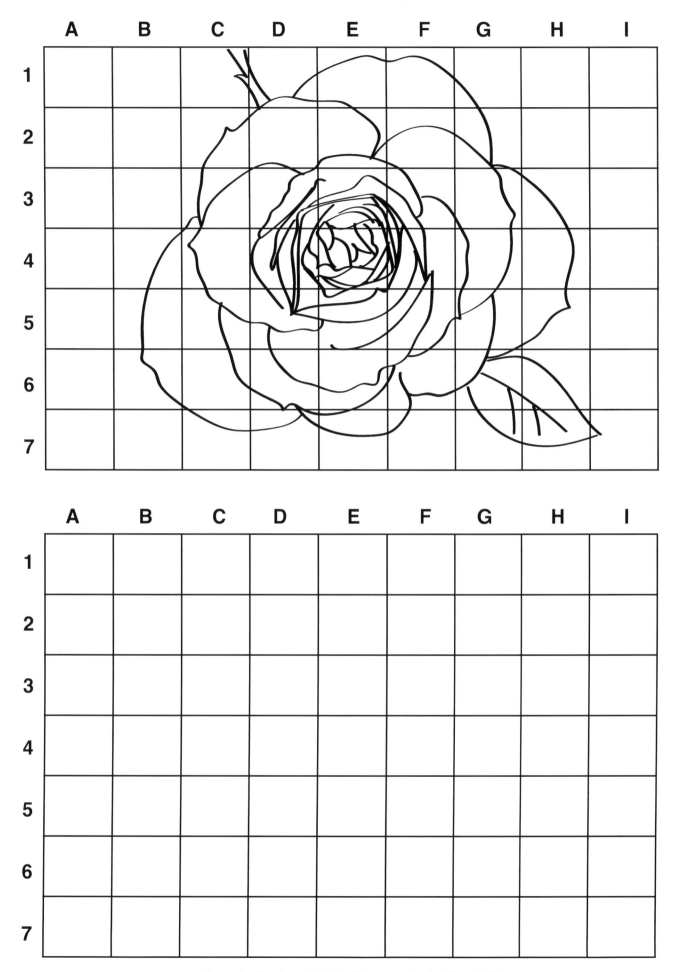

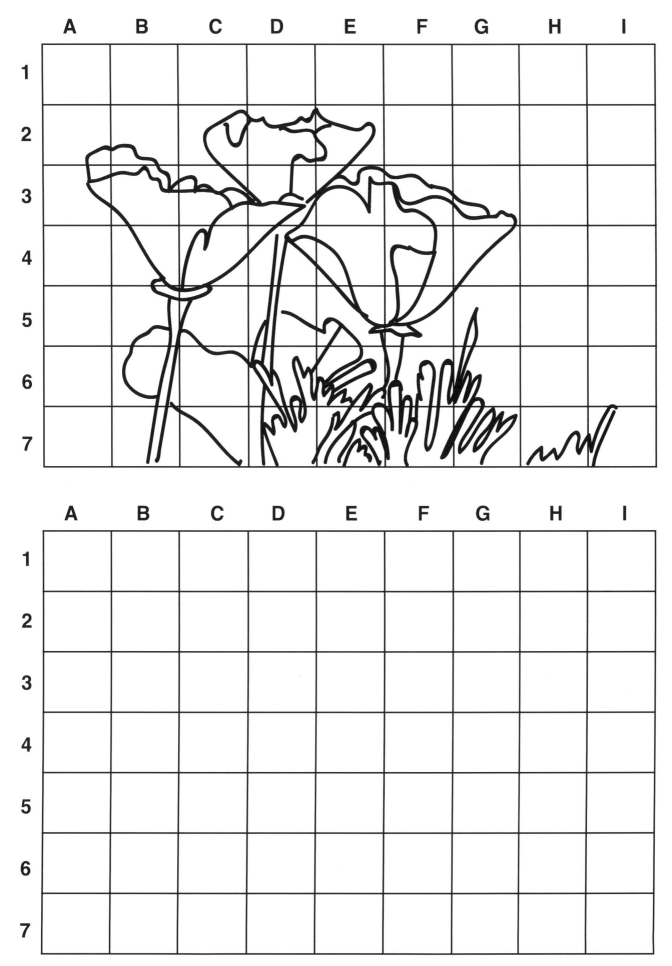

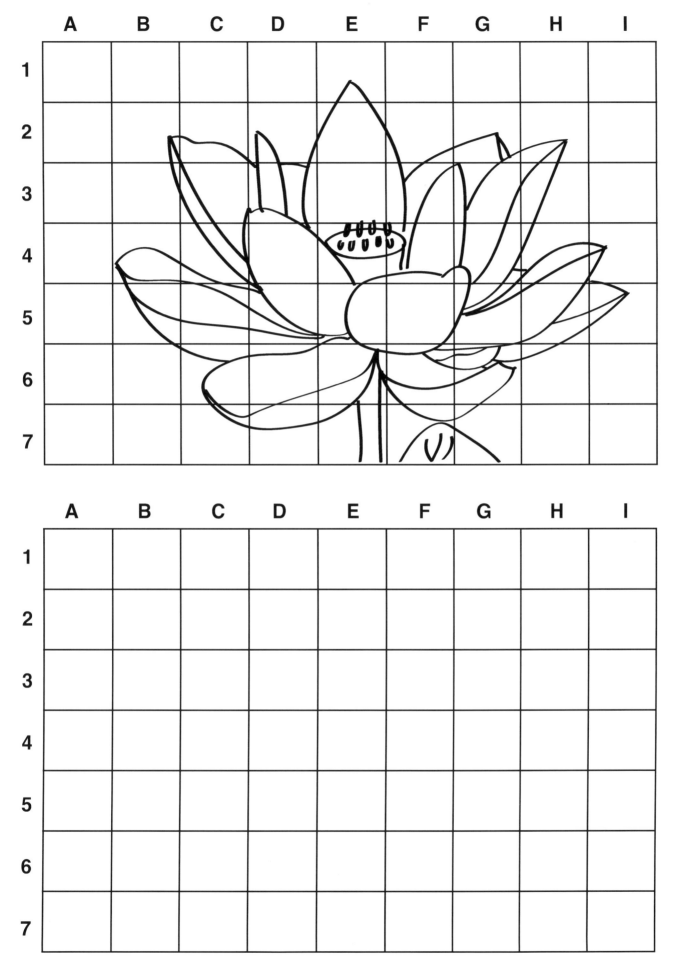

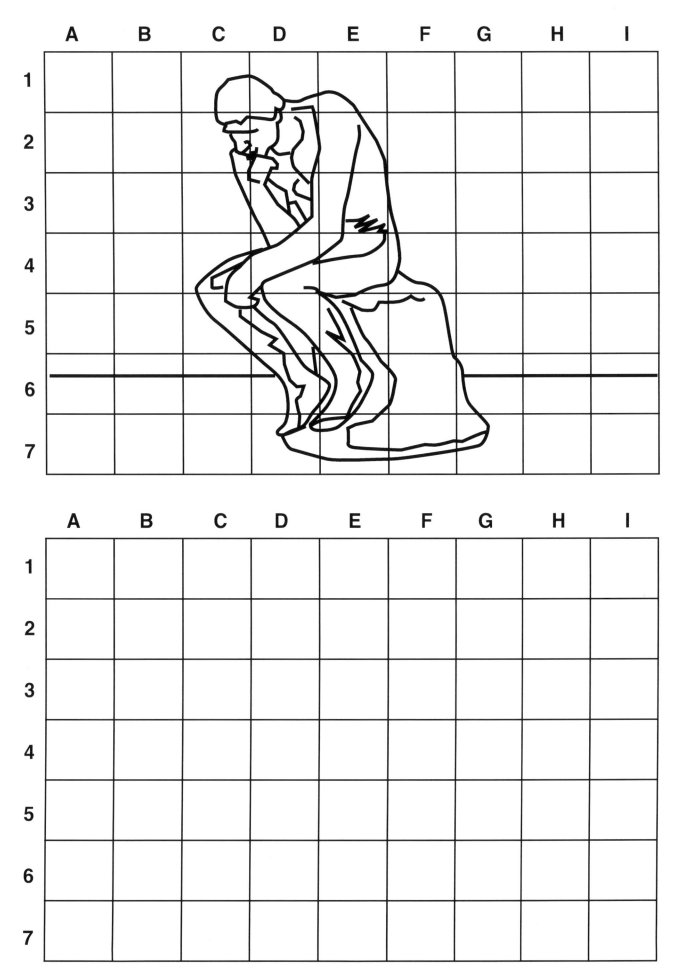

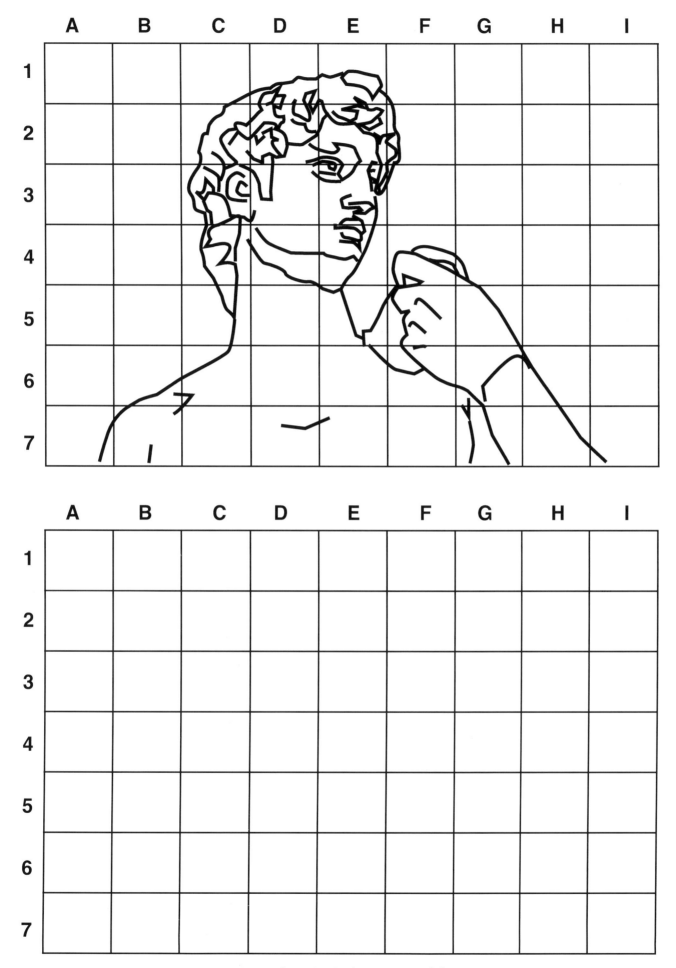

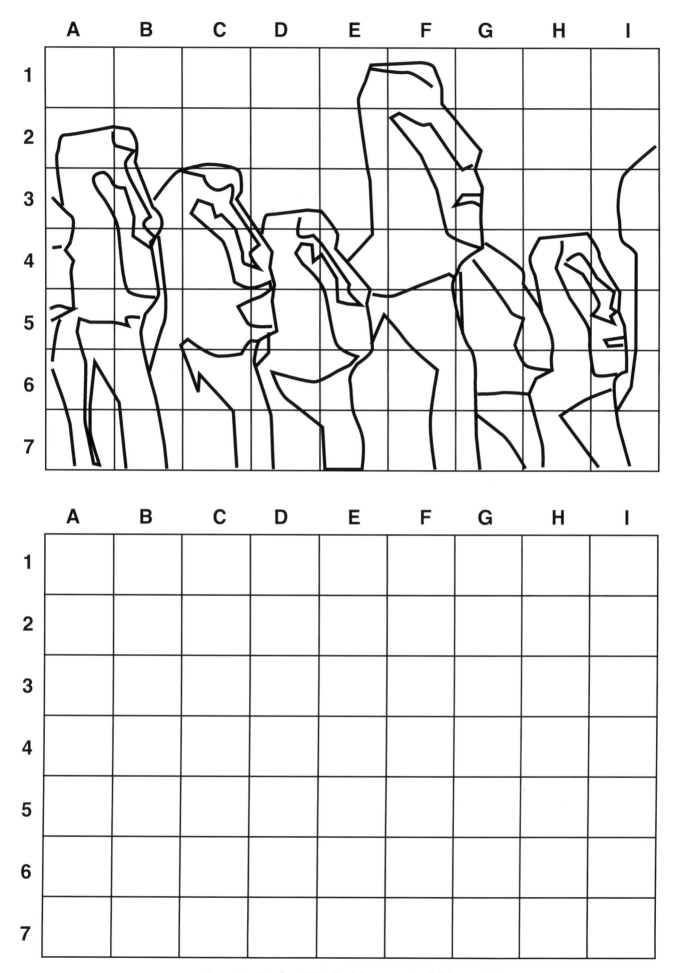

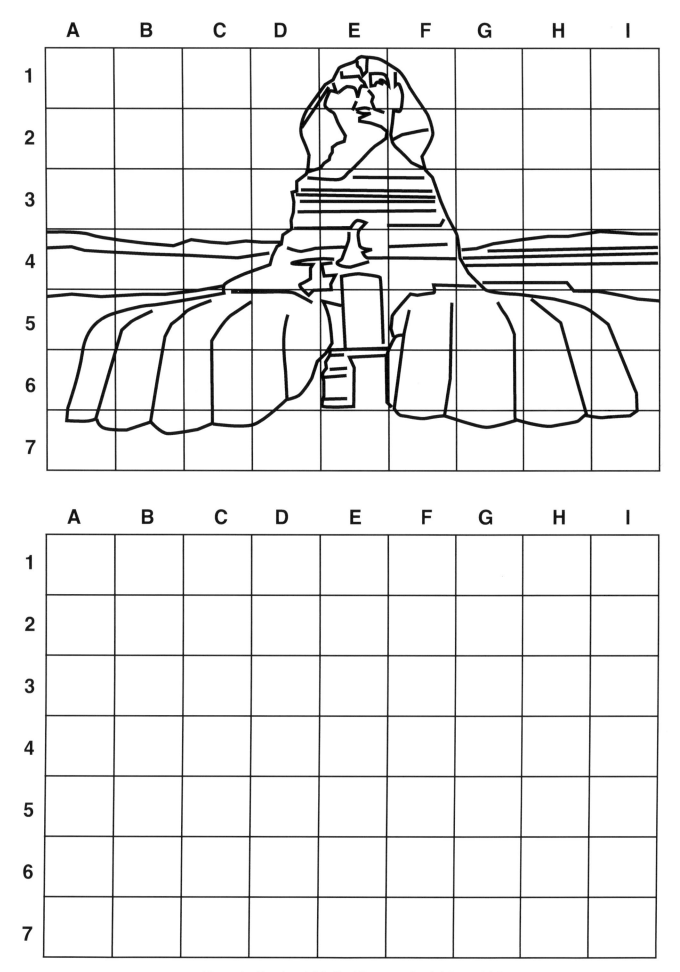

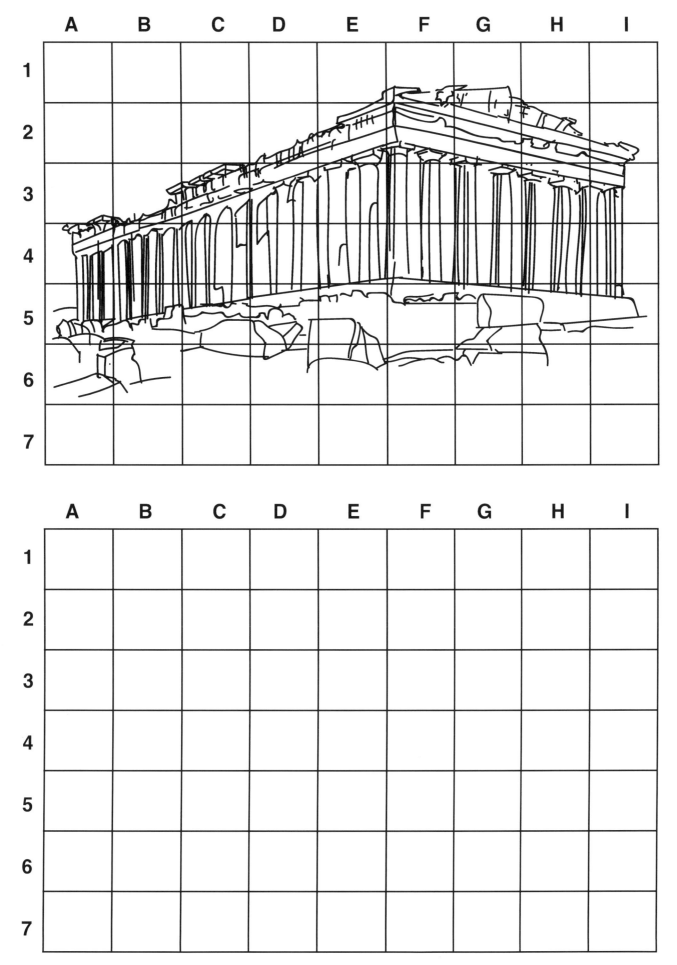

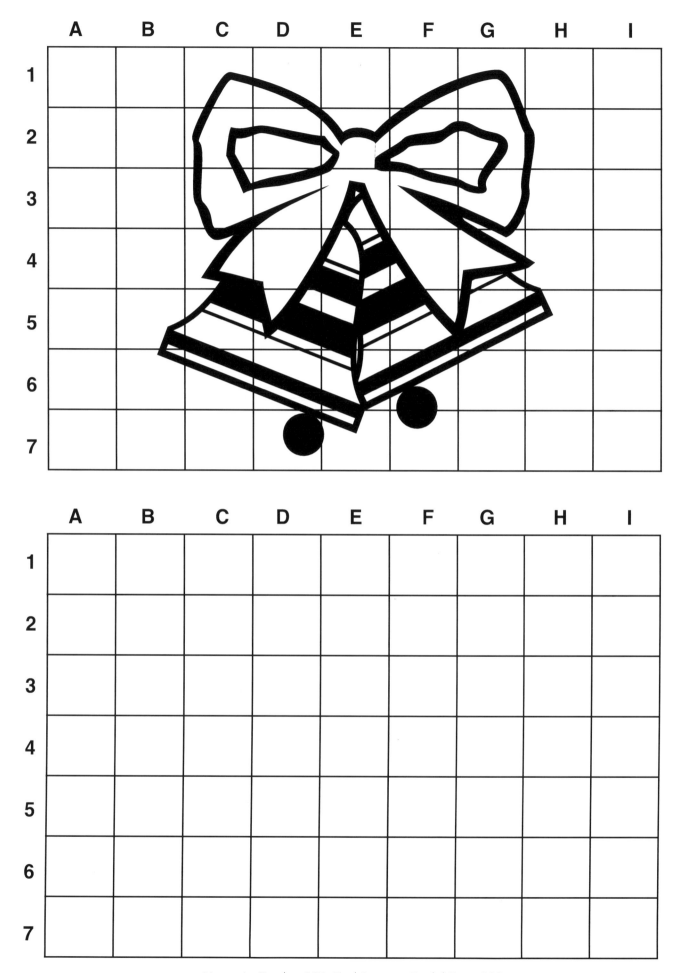

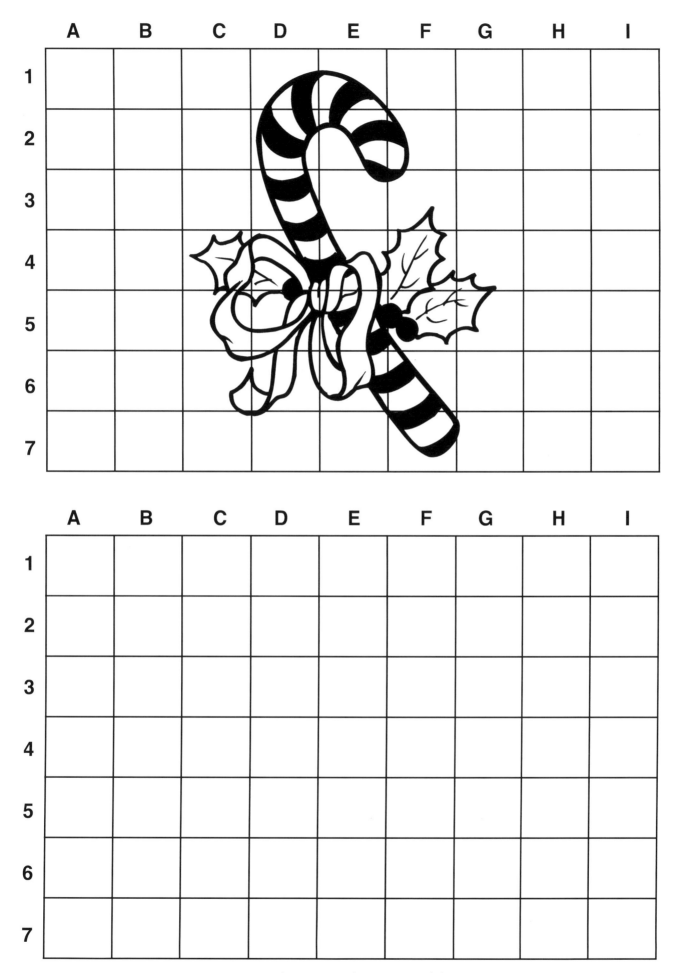

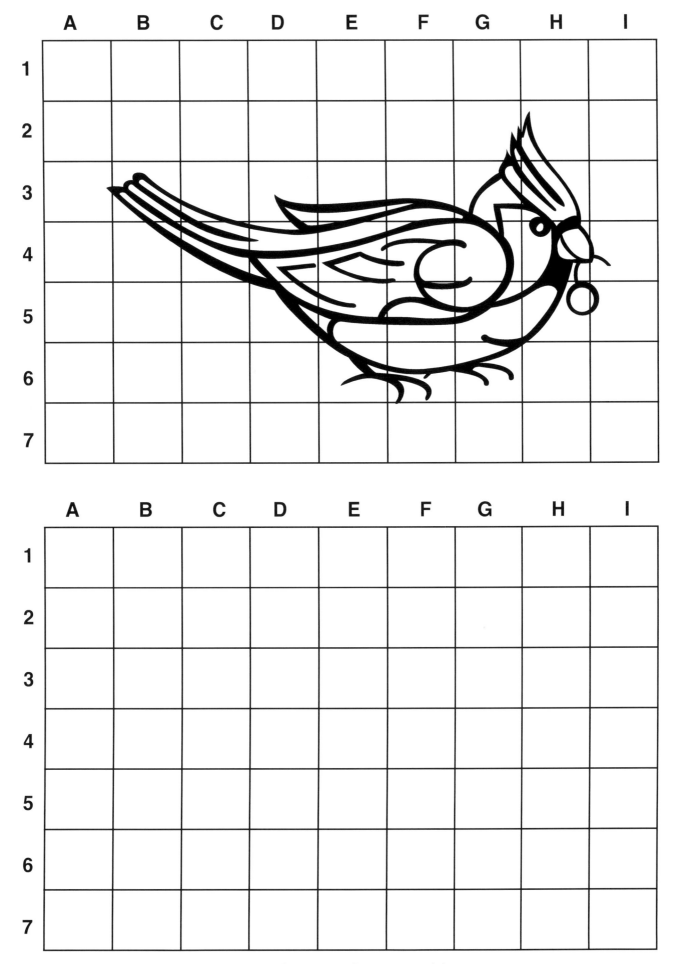

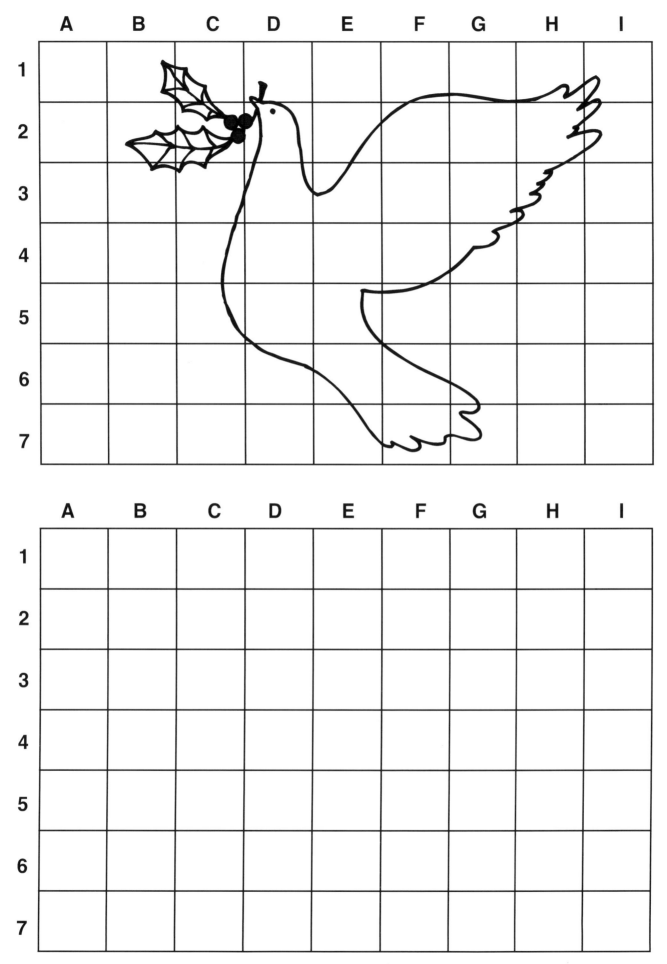

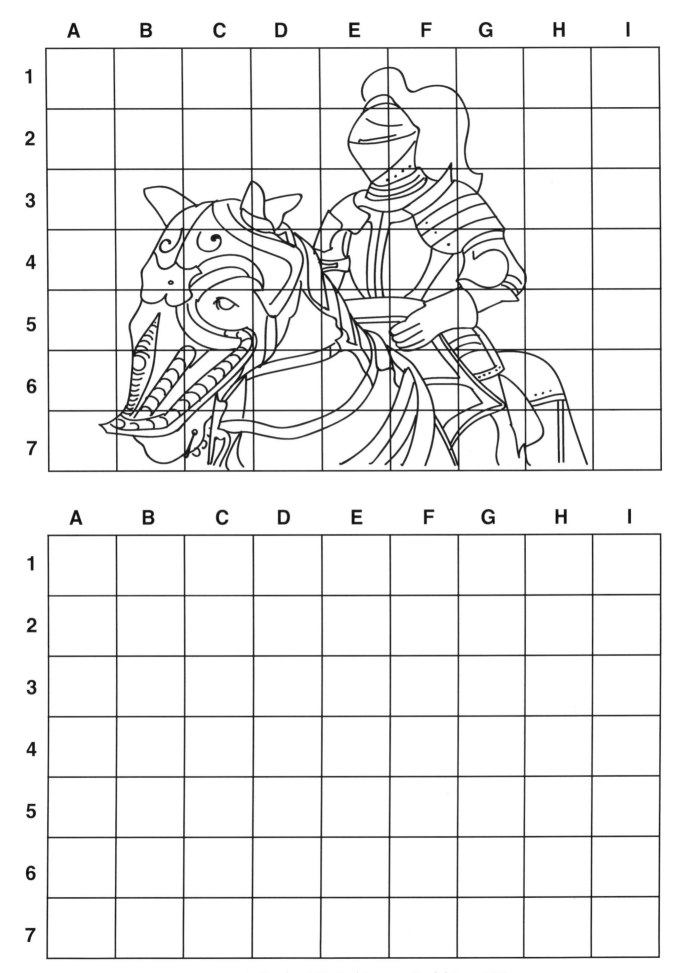

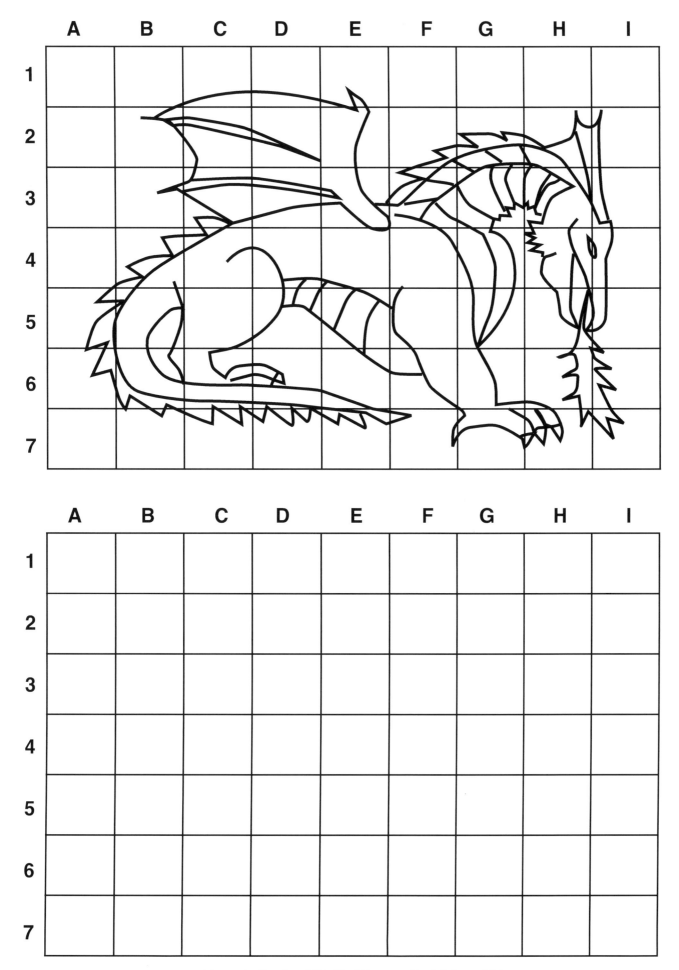

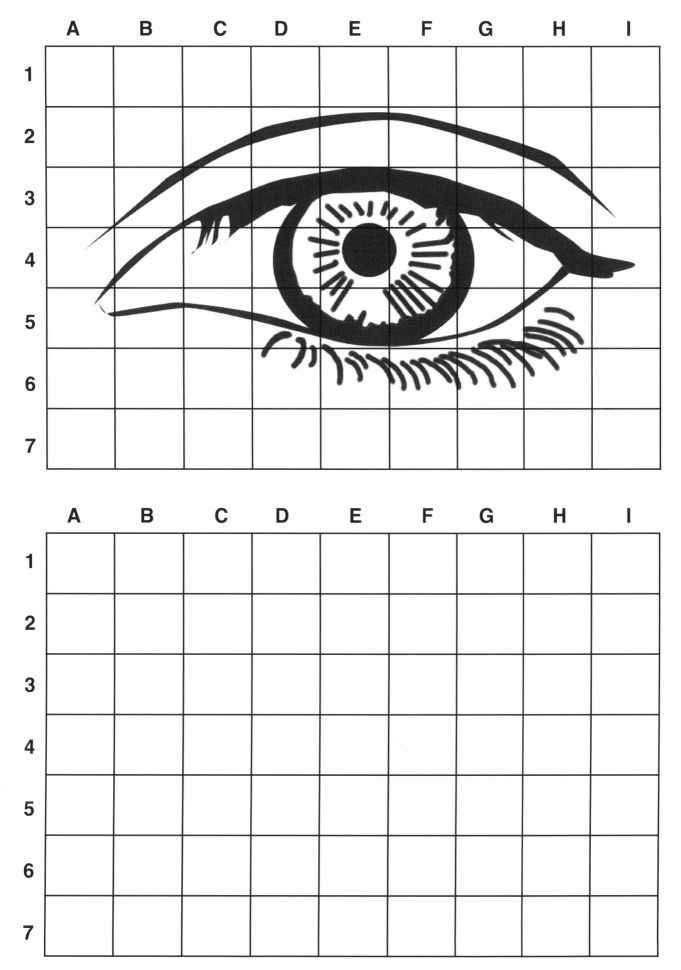

	A	B	C	D	E	F	G	H	I
1									
2									
3									
4									
5									
6									
7									

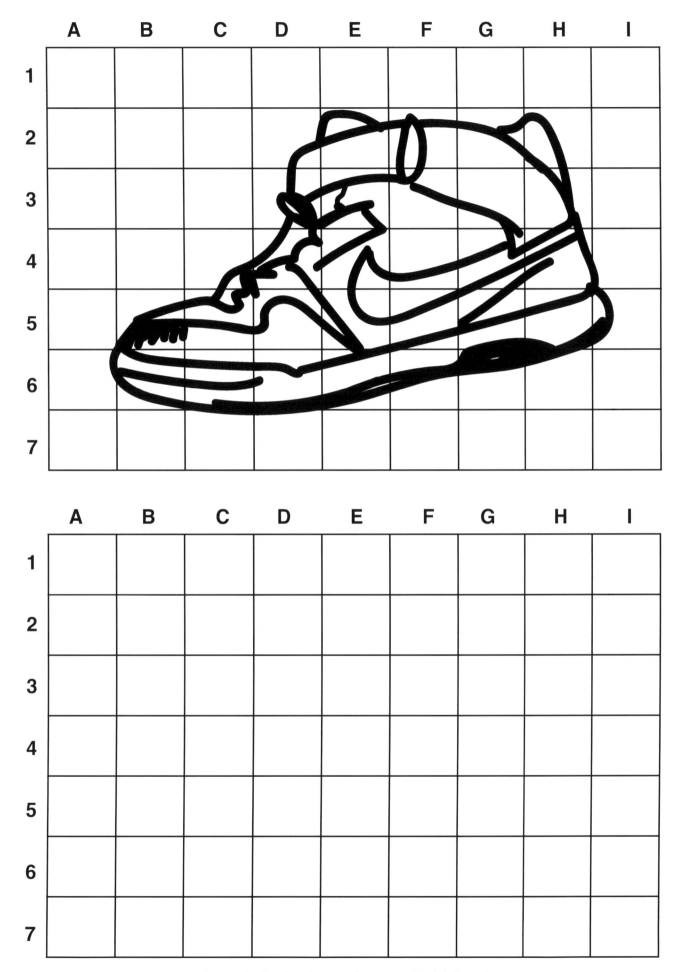

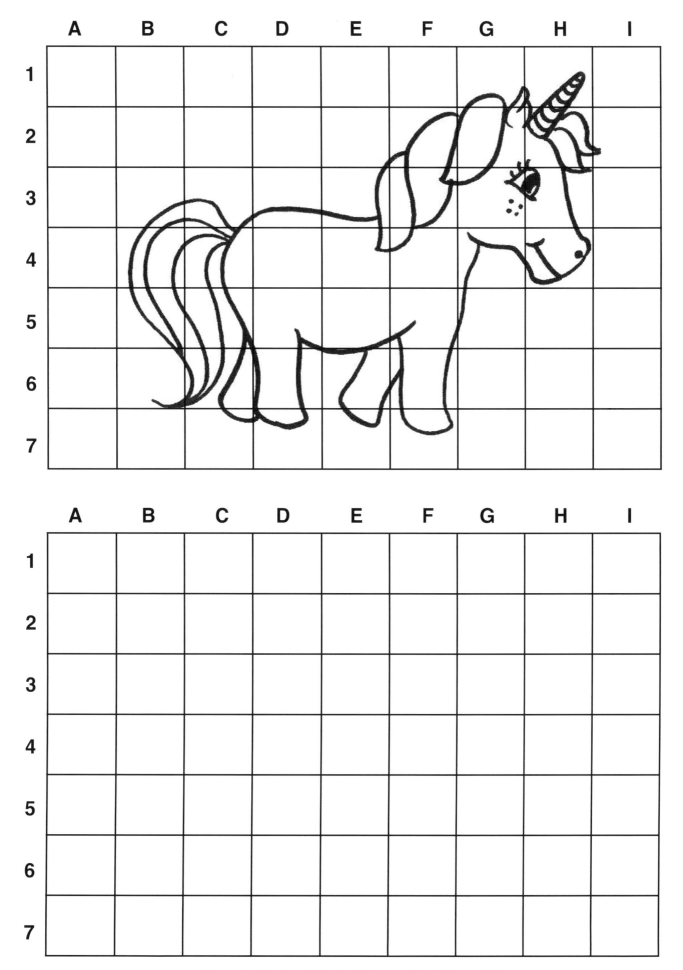

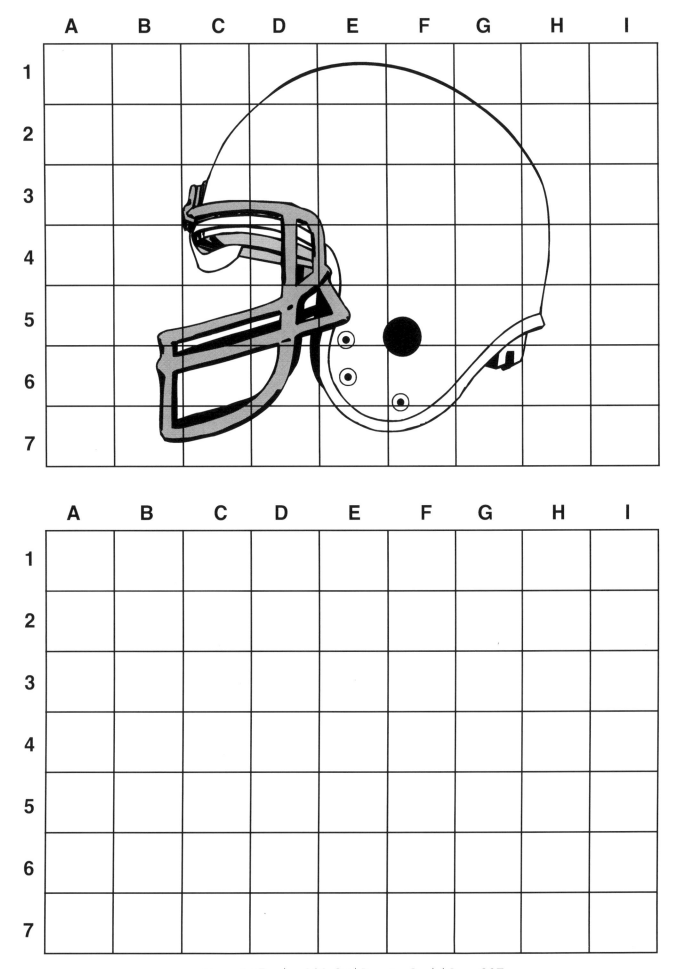

	A	B	C	D	E	F	G	H	I
1									
2									
3									
4									
5									
6									
7									

	A	B	C	D	E	F	G	H	I
1									
2									
3									
4									
5									
6									
7									